ELSTREE & BOREHAMWOOD

THROUGH TIME

Robert Bard

AMBERLEY PUBLISHING

For Chloe Keen

First published 2011

Amberley Publishing
The Hill, Stroud
Gloucestershire, GL5 4EP

www.amberley-books.com

Copyright © Robert Bard, 2011

The right of Robert Bard to be identified as the
Author of this work has been asserted in accordance
with the Copyrights, Designs and Patents Act 1988.

ISBN 978 1 4456 0631 6

British Library Cataloguing in Publication Data.
A catalogue record for this book is available from
the British Library.

Typeset in 9.5pt on 12pt Celeste.
Typesetting by Amberley Publishing.
Printed in the UK.

Introduction

Elstree and Borehamwood are both part of the borough of Hertsmere and are located 15 miles north of central London. Until relatively recently Elstree was the prevalent partner. As late as 1871 Elstree contained as few as 525 inhabitants, and Borehamwood, which was a 'hamlet of this parish', had a population of 800. With the opening of the railway station in 1868 and easy access to London, the area was to assume a new importance, primarily in the film industry, which came to the area in 1914. Borehamwood was to become the largest centre of film production outside of Hollywood.

Elstree is located on Watling Street, the old Roman road, which runs through the centre of the village. A short distance to the south of Elstree lies Brockley Hill, the site of the Roman settlement of Sullonicae. Roman pottery has been found in and around the village of Elstree, and off Allum Lane, indicating a continuous history of at least 2000 years. In antiquity the area of Watling Street that runs between Brockley Hill and Elstree was described as being 'almost of an impenetrable character, and so much infested by outlaws and beasts of prey that the numerous pilgrims who travelled along the Roman road for the purpose of devotion at the shrine of Albanus [were] exposed to very imminent danger.' Borehamwood has a history which goes back to the Domesday Book of 1086. The road which runs from Borehamwood to Radlett, on Watling Street, is Theobald Street. This was the original centre of Borehamwood. Well into the first quarter of the twentieth century the area remained largely rural. A description of Elstree village published in 1882 is still recognisable:

> At the entrance to the village from Brockley Hill, on the right-hand side of the road, is a large, old-fashioned red-brick mansion, called Elstree Hill House, which has now been converted into a collegiate school, and in the corner of a meadow on the opposite side of the road is a handsome brick-built church, of Gothic

design. The meadow is fringed with stately elms, and its farther side shelves down to Elstree Reservoir, a large sheet of water, which adds considerably to the beauty of the landscape.

Approaching Elstree from Stanmore along Watling Street, as one reaches Elstree High Street it is clear that much of historic interest can be identified among some modern buildings. Some demolition took place in the 1950s and 1960s, but a range of buildings dating from the fifteenth to the nineteenth centuries can still be found. The oldest is the Hollybush public house and the most impressive is an old mansion adjacent to the church, Schopwick Place, which dates from around 1720. Over the centuries Elstree has attracted its share of interesting visitors, residents and excitement. Charles Dickens was a frequent visitor to St Nicholas Church. Sir Richard Burton, the explorer, lived for a while at the now demolished Barham House in Barham Avenue. The shape of Barham Avenue reflects the old carriage driveway. Two murders caused local and national excitement. Martha Ray, born in Elstree in 1746, became a singer at Covent Garden and eventually the mistress of the Earl of Sandwich. On 14 April 1779 a jealous admirer shot her and was subsequently hanged. Martha Ray was buried in St Nicholas churchyard, Elstree, in an unmarked grave. In 1920, the then Earl of Sandwich had a tombstone erected over her grave. In 1823 the 'Elstree Murder', a great press sensation, took place. The victim, William Weare, was thrown into a pond near the corner of Watling Street and Allum Lane. On its discovery the body was removed to the Artichoke public house in Elstree Hill North where an inquest took place. On the dark and stormy night of 2 November 1823, Weare was buried on in an unmarked, but identifiable, grave in St Nicholas Churchyard. The area of the grave is still visible.

Borehamwood, meanwhile, developed faster than Elstree, undoubtedly due to the arrival of the railway. It became the haunt of numerous film and television stars. The MGM British complex and the Gate Studios have been demolished but a number of popular series are now filmed in the still thriving Borehamwood film studios.

As the pictures in this book show, Elstree and Borehamwood have both changed dramatically, particularly since the 1950s onwards. both however have managed to retain large areas of green, due to the failure in the 1930s to extend the Northern Line from Edgware, and the active preservation society. Much that was photographed over a century ago is still immediately recognisable. There are corners of both Elstree and Borehamwood that have escaped the developer's attention and allow us a glimpse into a much quieter, rural past. I have also included some old photographs of nearby Letchmore Heath, which reflect the general beauty of the area.

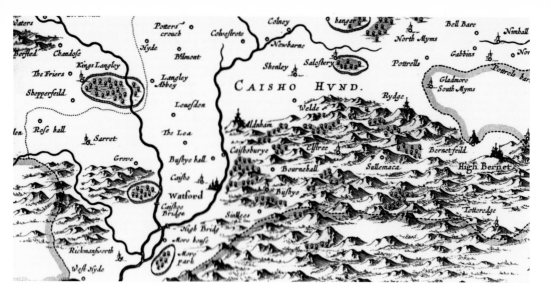

Tidulfes Treow and Bosci de Borham

Above is a detail from the Johan Blaeu 1648 map of Middlesex and Dacorum. Elstree with her church tower can be seen to the right of Watford. Elstree at Deacon's Hill lies 478 feet above sea level. The town's name evolved from 'Tidulfes Treow' in 785 to Elstree in 1675. Borehamwood originated as 'Bosci de Borham' in 1188, changing to 'Barramwoode' by 1554. Below is the Dury map, 1766, showing detail of Elstree and 'Barham Wood'. Aldenham House home of Robert Hucks, now Haberdashers' Aske's School, can be seen, as can Elstree village and Allum Lane leading towards Borehamwood.

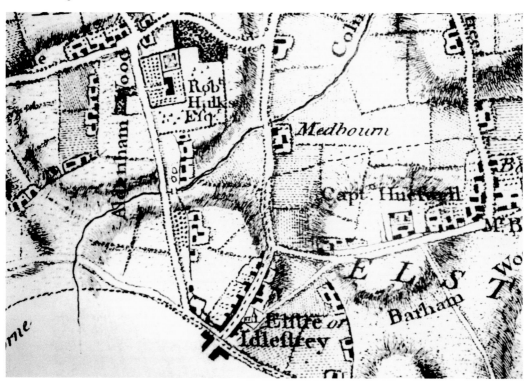

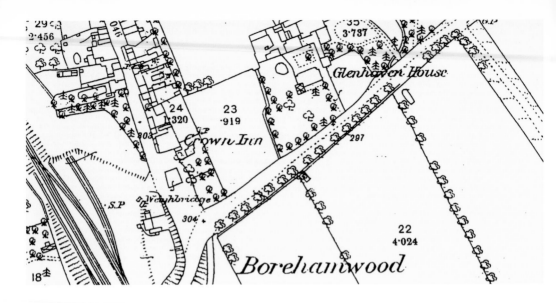

Elstree and Borehamwood

The 1872 Ordnance Survey map of Borehamwood, above, depicts a small village that was about to slowly develop, thanks to the arrival of the railway in 1868. The map shows the old Crown Inn and a settlement based along Theobald Street. A directory entry in 1854 called Borehamwood a village that 'contains many respectable detached residences.' Glenhaven House is remembered now by Glenhaven Avenue. The 1898 Ordnance Survey map of Elstree, below, shows the village with Watling Street the focal centre. Many of the key buildings shown still exist. The Plough is now The East, a Chinese restaurant. By 1890 Borehamwood was developing while Elstree remained static.

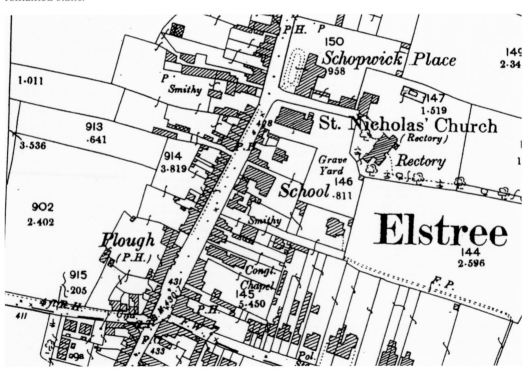

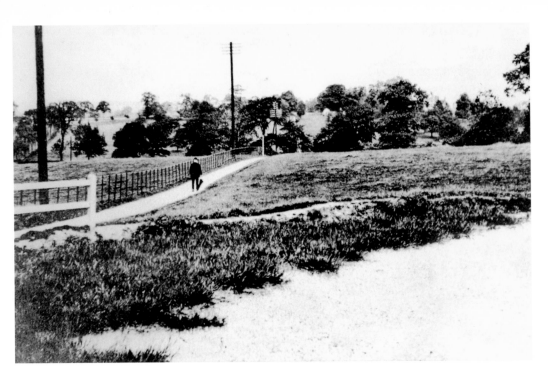

Four Fields

Four Fields has changed little over the last century. The old picture dates from 1905. The path is a cut-through from Allum Lane to the War Memorial in Elstree. The village lies in the distance on the hilltop.

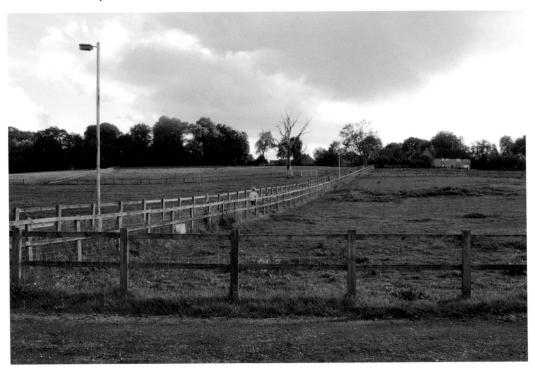

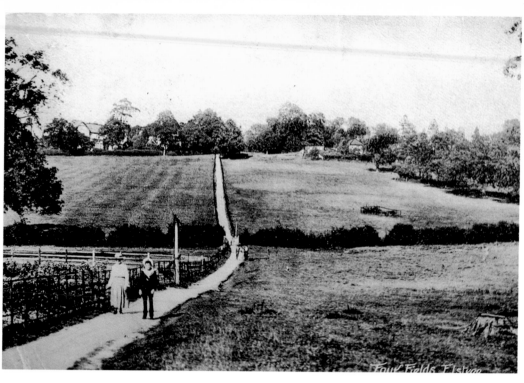

Allum Lane

Another photograph of similar date is taken with Elstree village behind. The path runs parallel to Watling Street. A signpost off of Allum Lane indicates the rubbish tip.

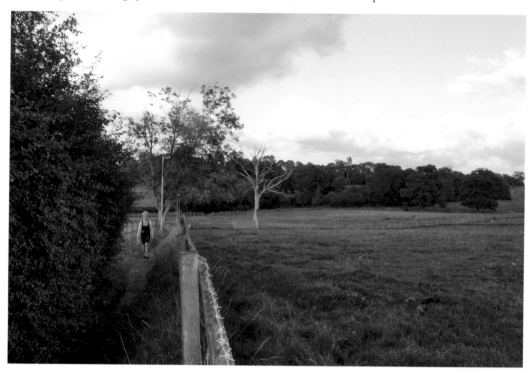

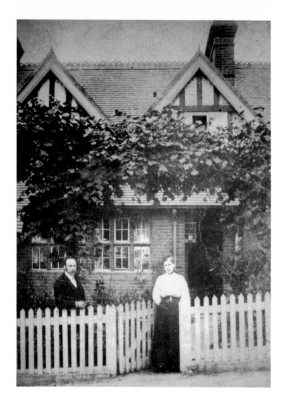

Alfred Burridge

This photograph of Alfred Burridge and his wife outside their home at 7 Elstree Hill North dates from sometime between 1903 and 1910. The house still stands near the corner of Allum Lane. It was one of a number of workers' cottages built at the end of the nineteenth century by Lord Aldenham to house estate workers.

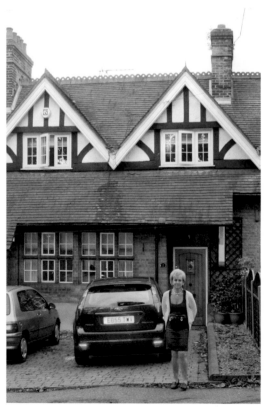

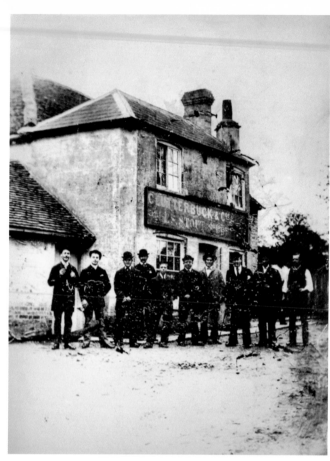

The Artichoke
A short distance from the junction with Allum Lane was the Artichoke public house. The building is still standing but derelict. It is first mentioned in 1750 and it was here that a number of inquests took place. The Birmingham to London stagecoach also stopped here. twice daily in the 1830s.

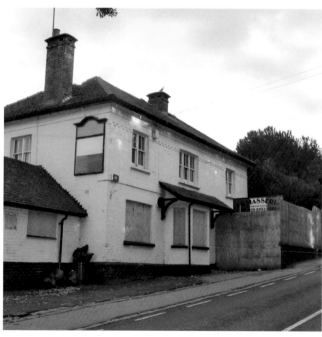

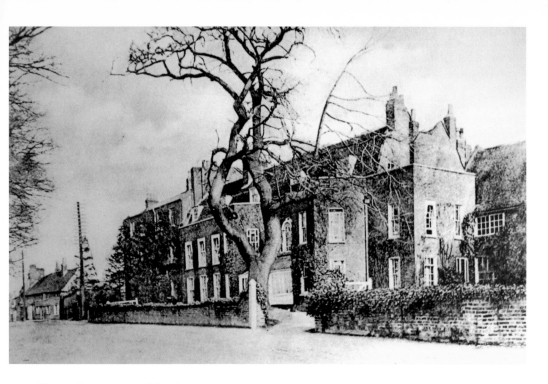

Elstree Preparatory School

The photograph dates from 1903. The house remains, near the junction in Elstree village on Elstree Hill South, and is now a BUPA nursing home. The building dates from 1779. Between 1847 and 1939 it was Elstree Preparatory School. The tree in front of the building in 1903 is still standing.

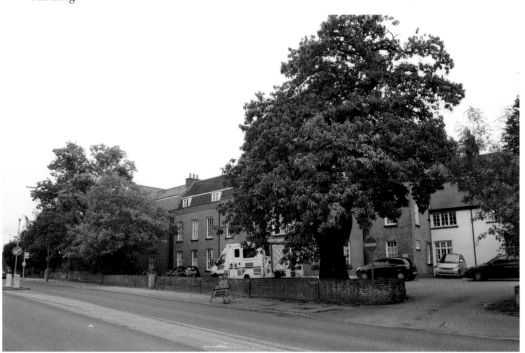

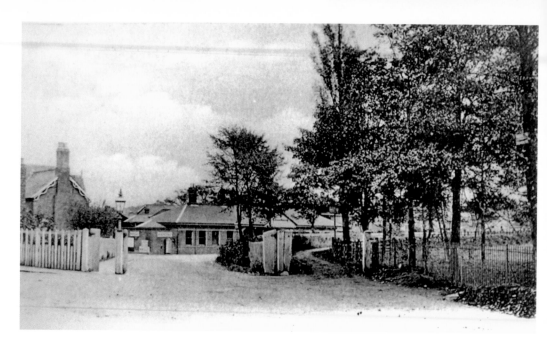

Elstree Station

Elstree station in 1903. The station opened on 13 July 1868 with six trains running daily in each direction. The stationmaster's house visible in the old photograph dates from 1867/68 and was recently demolished to make way for a proposed block of flats. The year 1874 saw two accidents near the station; the second one resulted in the death of a passenger and several injuries.

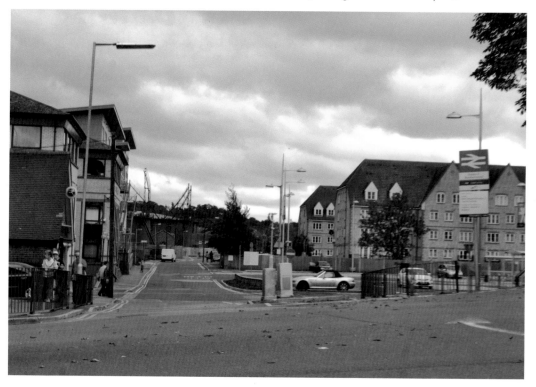

L M S
LONDON MIDLAND AND SCOTTISH RAILWAY

EASTER HOLIDAY.

COOK'S
HALF-DAY EXCURSION
TO
ELSTREE, RADLETT, ST. ALBANS HARPENDEN & LUTON,

On MONDAY, APRIL 21st, 1924
WILL RUN AS UNDER:

FROM	Times of starting	RETURN FARES—THIRD CLASS				
		To Elstree	To Radlett	To St. Albans	To Harpenden	To Luton
	p.m.	s. d.	s. d.	s. d.	s. d.	s. d.
ST. PANCRAS	12.35	1 7	1 11	2 6	3 1	3 9
Kentish Town	12.42	1 5	1 8	2 4	2 11	3 7
Finchley Road	12.48	1 2	1 6	2 1	2 8	3 5
West Hampstead	12.52	1 1	1 6	2 0	2 7	3 4
Cricklewood	12.56	1 0	1 3	1 10	2 5	3 2
Hendon	1.2	0 9	1 0	1 8	2 2	2 11
Mill Hill	1.8	0 5	0 9	1 4	1 11	2 8
Elstree	1.15	—	0 5	1 0	1 6	2 3
Radlett	1.20	—	—	0 7	1 3	1 11

RETURN ARRANGEMENTS. Passengers must return same day as under
From Luton at 7.40 p.m.; Harpenden at 7.53 p.m.; St. Albans at 8.5 p.m.
Radlett at 8.13 p.m.; Elstree at 8.21 p.m.

PASSENGERS ARE REQUESTED TO OBTAIN TICKETS IN ADVANCE.
Tickets can be purchased at the "MIDLAND" STATIONS, and Offices of
THOS. COOK & SON.

CONDITIONS OF ISSUE OF TICKETS.
CHILDREN under three years of age, free; three years and under twelve, half-fares.
NOTICE.—The tickets are not transferable, and will be available on the date of issue only, by the trains, and at the stations named; if used on any other train, or at any other station than those named, the tickets will be forfeited and the full ordinary fare charged.
The Company give notice that tickets for this excursion are issued at a reduced rate, and subject to the condition that the Company shall not be liable for any loss, damage, injury, or delay to passengers arising from any cause whatsoever.
No luggage allowed.
Should the Company consider it necessary or desirable, from any cause, to alter or cancel these arrangements, they reserve to themselves the right to do so.

March, 1924. **H. G. BURGESS, General Manager.**

R 18/24E. Thos. Cook & Son, Print &c., Ludgate Circus, London, E.C.4.

Elstree Station
The timetable for 21 April 1924 demonstrates the still rural nature of destinations such as Elstree and Luton. The excursion advertised is offered by Thomas Cook & Son. Below, Elstree's film heritage trail is clearly visible on arrival at the station.

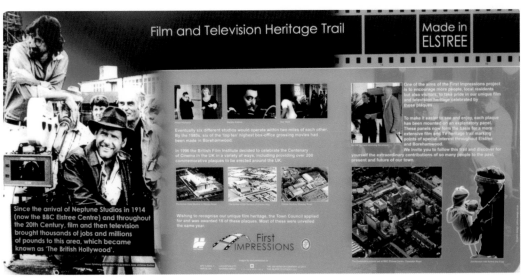

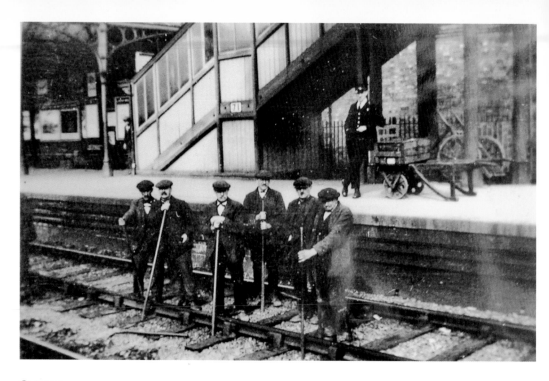

Gangers

This photograph, taken on the line at Elstree station in 1923, shows 'gangers' working on the track. The modern photograph shows the footbridge from platform one, which was added in 1895.

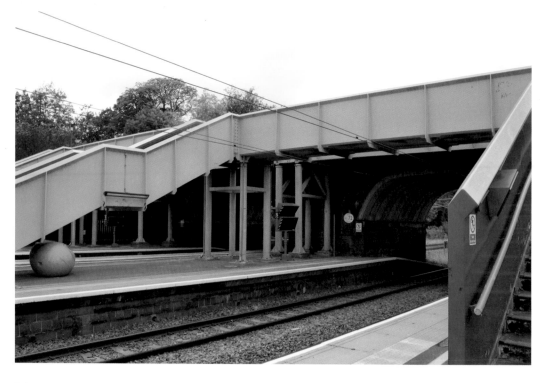

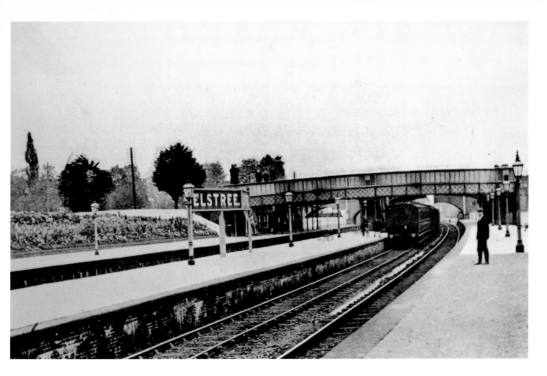

Changes at Elstree Station

Elstree Station, taken in 1903. The view is looking to the north. The train is waiting at platform three, which is now platform two. In 1895 the Midland Railway was widened to four tracks. Platform four, now platform one, and the footbridge were added at this time.

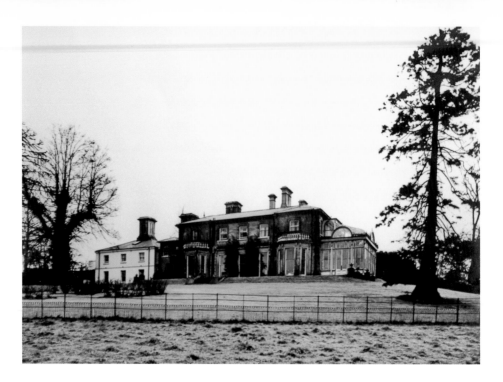

Deacon's Hill House

Deacon's Hill House was the home of Lord Aldenham's brother, George Louis Monck Gibbs. He was responsible for the building of Deacon's Hill Road, originally a private driveway from his house to Elstree Station, which opened in 1868. The house dated from the early nineteenth century. George Gibbs died in 1881 as a result of a hunting accident. The house was demolished in the 1960s. It stood on the south side of Barnet Lane, near the junction with Deacon's Hill Road. Deacon's Heights now stands on the site.

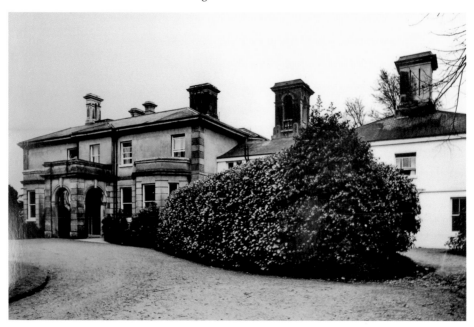

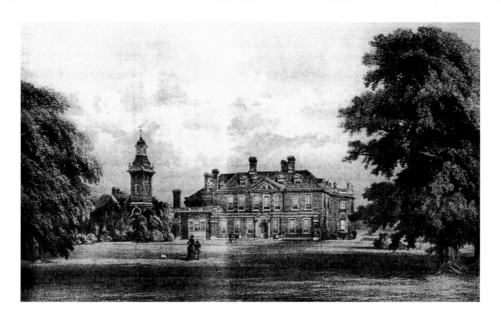

Haberdashers' Aske's School

Haberdashers' Aske's School, formerly Aldenham House. This building in Butterfly Lane sits on an estate recorded as far back as 1275. There are still traces of a moat just inside the main gates. Aldenham House was begun by Henry Coghill in the 1630s. In 1728 it passed by marriage into the Gibbs family. A later member of the family, Henry Hucks Gibbs, Governor of the Bank of England, and believed to be the richest man in England, became the first Lord Aldenham. By 1932 the property stood empty. After a couple of unsuccessful ventures, the BBC leased the estate in 1941. In 1959 the Haberdashers' Company transferred their school from north London to Aldenham House.

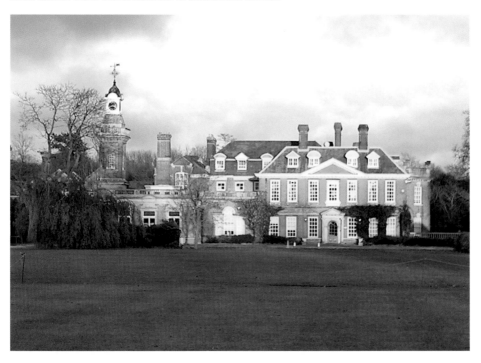

Aldenham House

The photograph above, taken in about 1905, shows a bridge from the Vicary Gibbs era, which still stands exactly as it was then, just inside the gates to Haberdashers' School in Butterfly Lane. By 1910 Aldenham House was occupied by the second son of the late Lord Aldenham, Vicary. The photograph below shows some of the staff from this era.

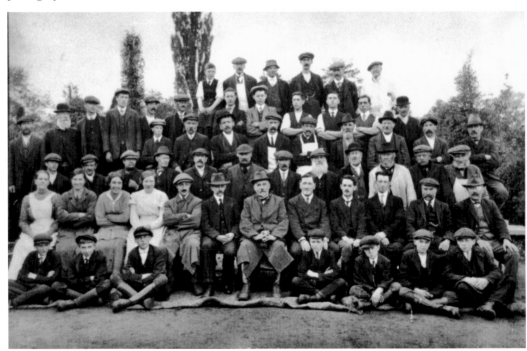

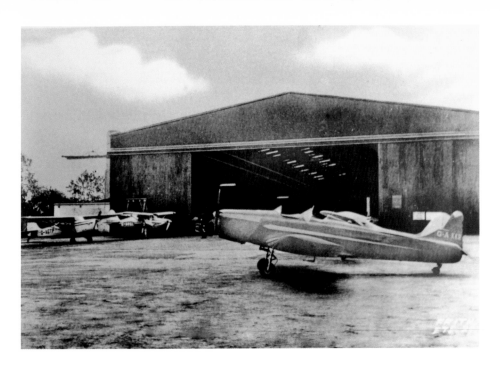

Elstree Aerodrome

Elstree Aerodrome, originally known as Aldenham Aerodrome was founded in 1934. After the death of Vicary Gibbs in 1932 the house had become a health resort and the aerodrome was used to fly in guests. Visiting Hollywood film producers in the 1930s made the new London Air Flying Club popular. It was during the Second World War that a concrete runway was built for the repair of Wellington bombers, and three new hangars were added.

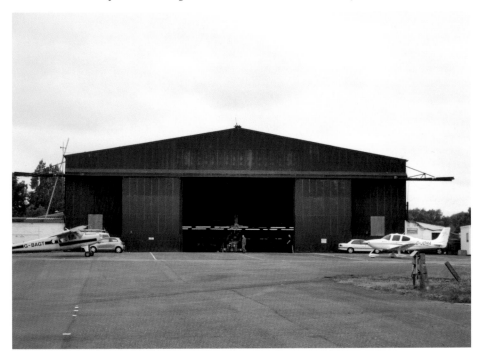

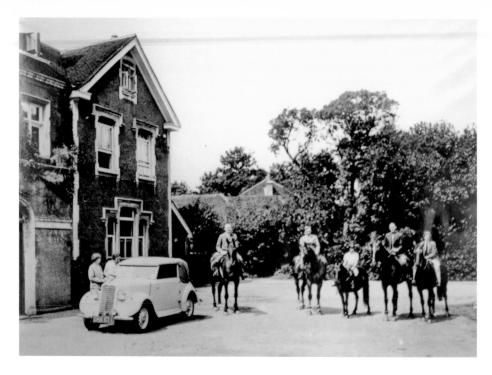

Radnor Hall

Elstree's location on the periphery of London made it a popular place to locate one's country house. Radnor Hall, a seventeenth-century mansion with lodge, stood just off Allum Lane on the south side, near the junction with Watling Street. By the 1930s it had become a country club, and was demolished in the 1950s. It stood where the Allum Lane rubbish tip now stands. The only reminder of its former presence is the lodge. The early photograph dates from the 1930s.

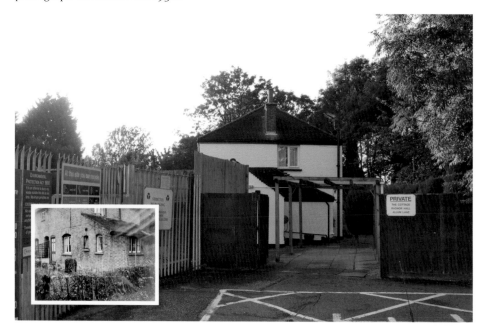

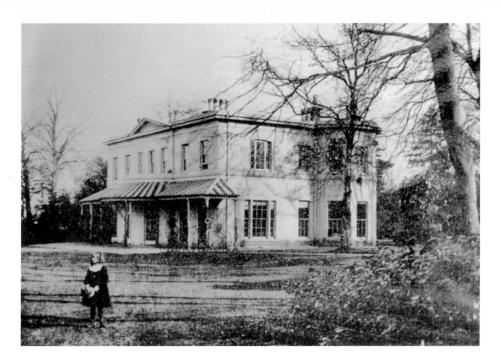

Barham House

Barham House, now demolished, was built in the 1680s. The first owner was Edward Wortley-Montague. By 1789 the property was sold to William Putland who built the coach house that still stands on the corner of Allum Lane and Barham Avenue. The house itself was demolished in 1931 to allow the development of Barham Avenue. Barham Avenue comprises mainly the former carriage driveway. The pair of houses named Barham House in the modern photograph are in fact the original coach house.

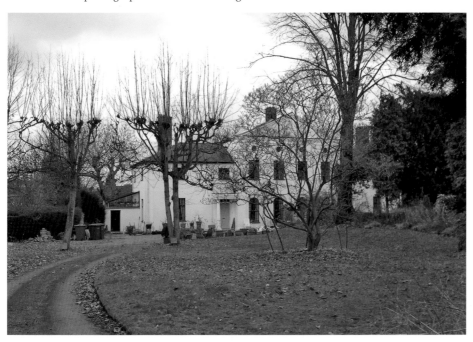

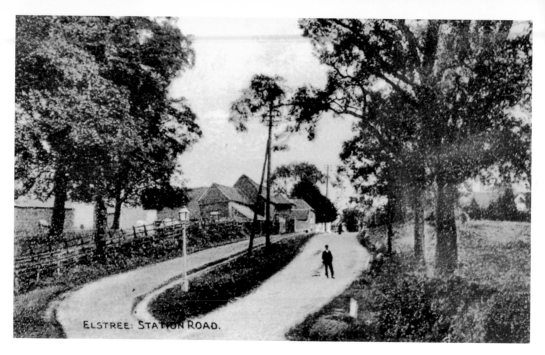

ELSTREE: STATION ROAD.

Nicholl Farm

Elstree Station Road was an alternative name to Allum Lane. This picture from around 1903 is taken with Watling Street to the rear, looking towards Nicholl Farm. The road can be seen to split in the middle. As can be seen from the modern picture, the split is still there, as is Nicholl Farm, one of Elstree's oldest buildings. During the Second World War a German bomb fell at this spot, causing no injury.

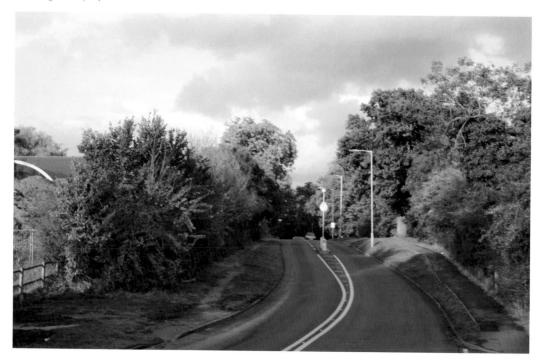

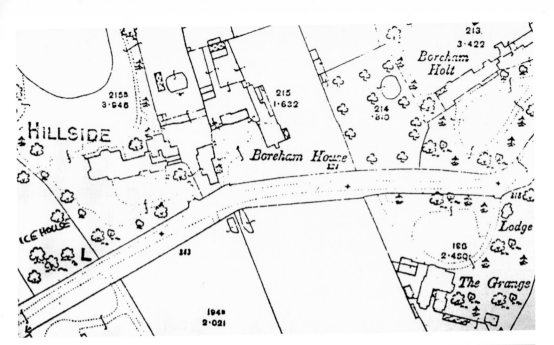

Allum Lane
Map of Allum Lane in 1931 showing Barham House and its grounds prior to its demolition. The below picture shows haymaking in Allum Lane, in 1931. The area around the lane is still largely rural farmland.

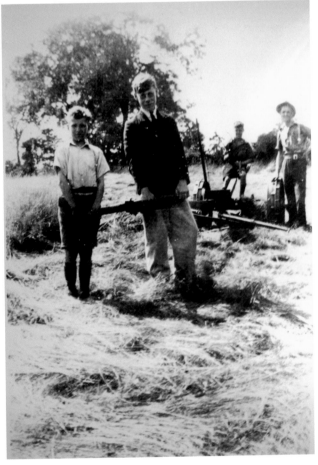

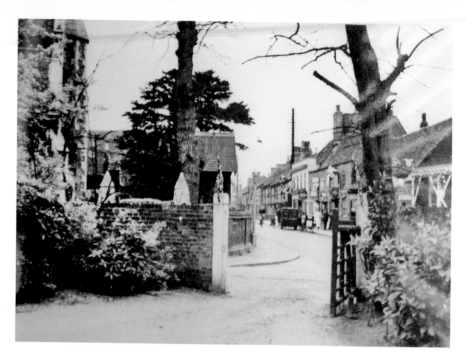

Schopwick Place

Below, standing just north of the parish church in Elstree High Street, we see Schopwick Place. The existing building probably dates to around 1722, and this illustration is from around 1800. Schopwick Place is best known as the former home of Sir Percy Everett. He was a friend of Lord Baden-Powell, founder of the Scout movement, in which Everett was also closely involved. The picture above is a view from Schopwick looking towards Elstree High street in 1937.

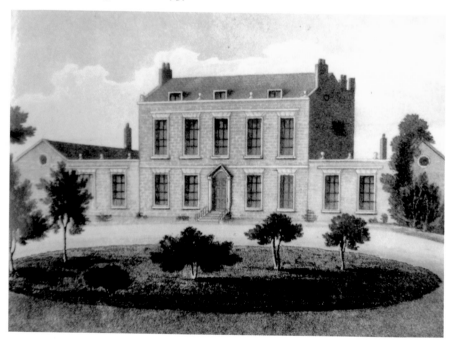

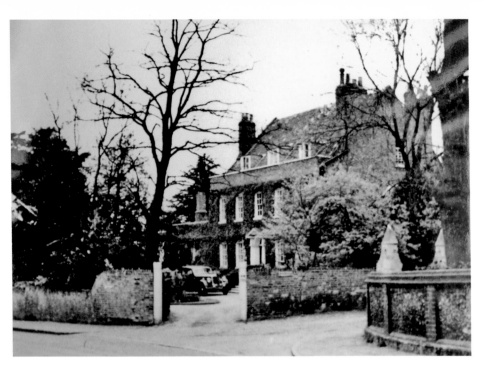

Elstree Hall
Schopwick Place *c.* 1925. Within the ground of Schopwick Place grounds lie the former site of Elstree Hall which dated to the early sixteenth century and was demolished in 1888.

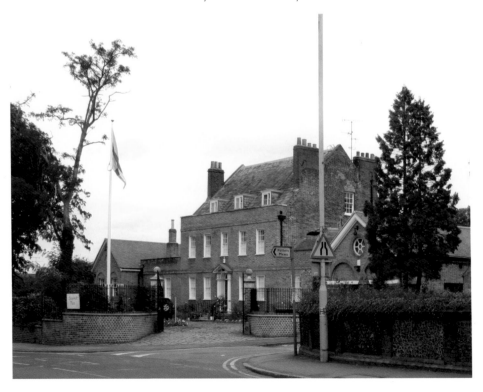

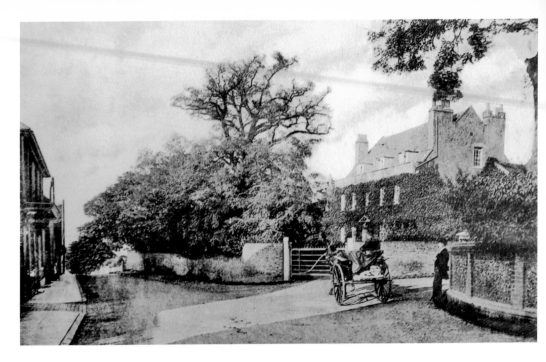

Schopwick Place

This photograph from around 1905 shows Schopwick Place looking from south to north. To the left are a number of seventeenth-century buildings, which are now the site of modern houses.

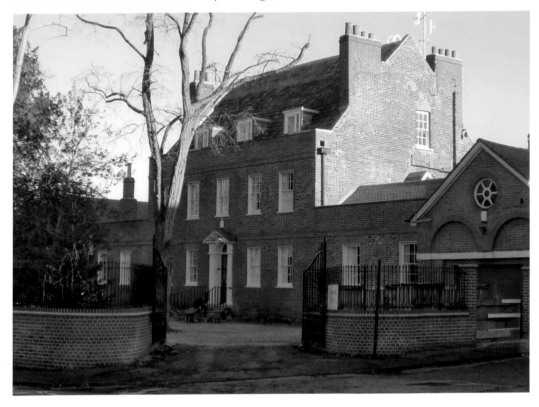

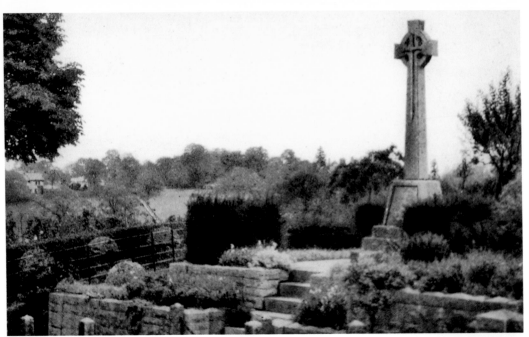

Elstree War Memorial
Elstree War Memorial was dedicated
on 14 July 1921. The vista behind the
memorial remains rural in 2011.

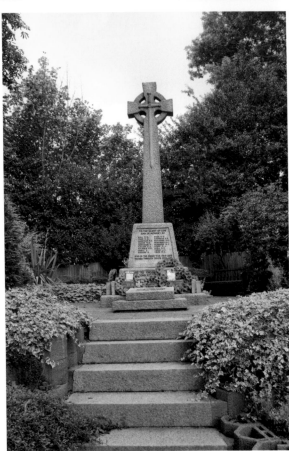

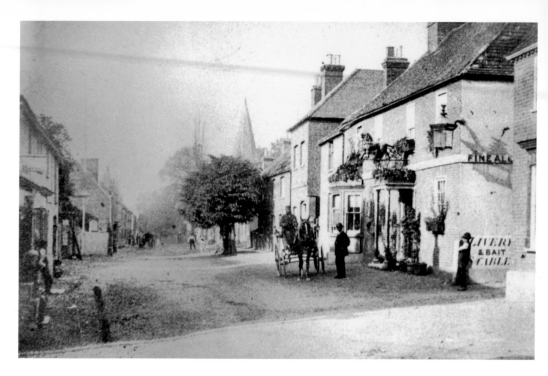

The Red Lion

Elstree High Street in the 1880s looking from the south to the north. The picture was taken on the south side of the crossroads before they were widened. The Red Lion can be seen on the right. It was first mentioned in the records in 1656, and was demolished in 1936.

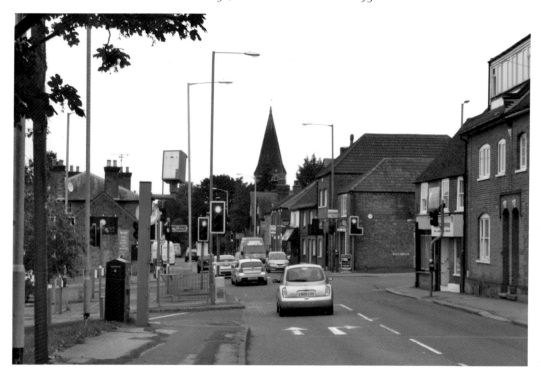

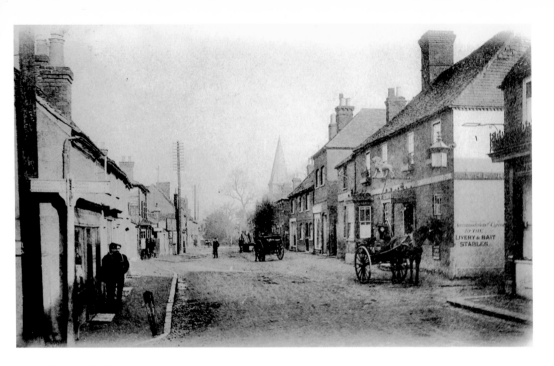

Elstree High Street

Elstree High Street *c.* 1890. The above photograph highlights the rural nature of Elstree in the 1890s despite its location on Watling Street. The photograph below of the High Street dates from around 1900 and shows the Hollybush, one of the oldest buildings in Elstree, at the bottom of High Street on the left.

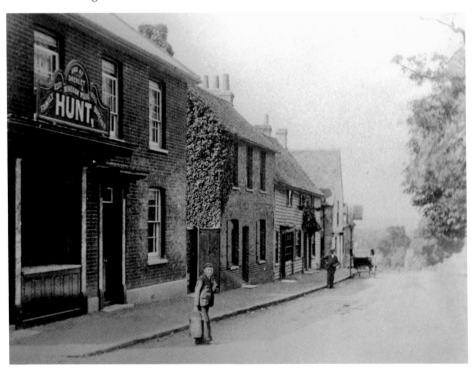

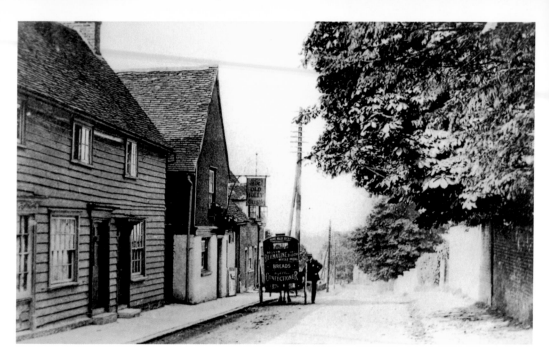

The Hollybush

The Hollybush in 1903. The building, now empty, dates from around 1450 and has been featured on the television programme *Most Haunted*. It has been described by a local historian as 'a fine example of a timber-framed hall house.'

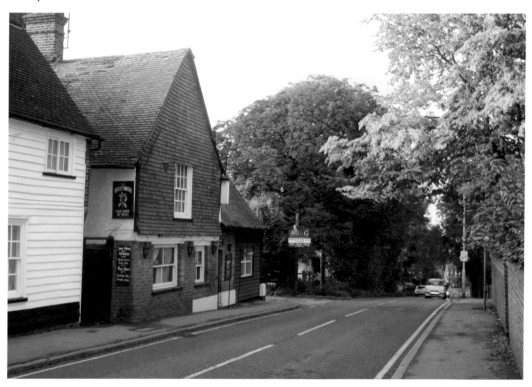

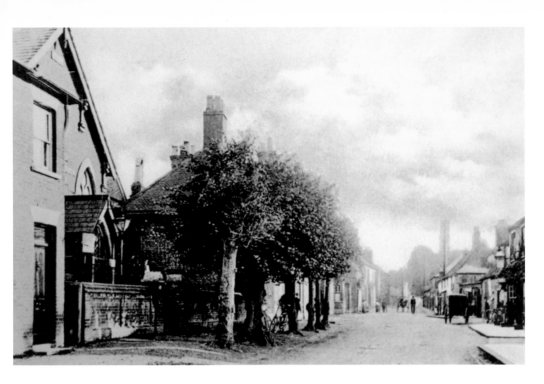

The Baptist Chapel
In this view of the High Street in 1905 the Baptist Chapel, which was built in 1876, can be seen on the left.

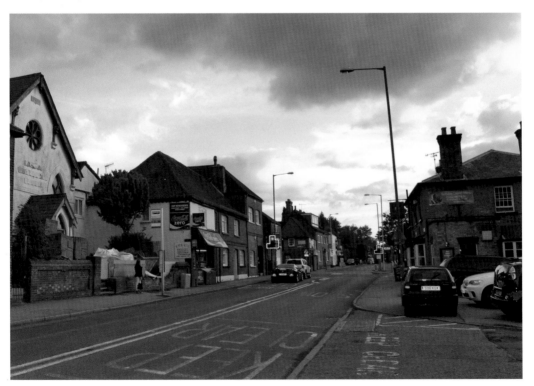

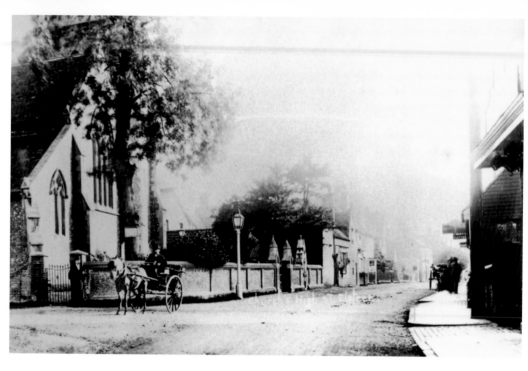

Rural Elstree

Elstree High Street in 1909 still retains its rural aspect. The photograph shows a pony and trap outside St Nicholas Church, looking to the south.

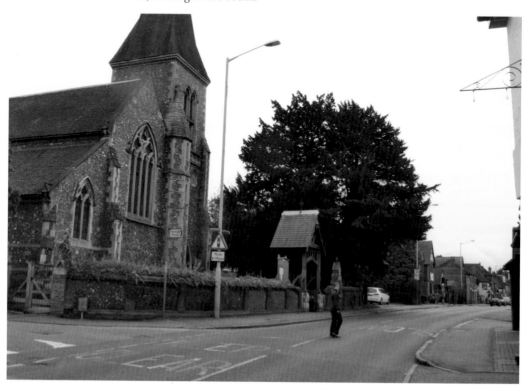

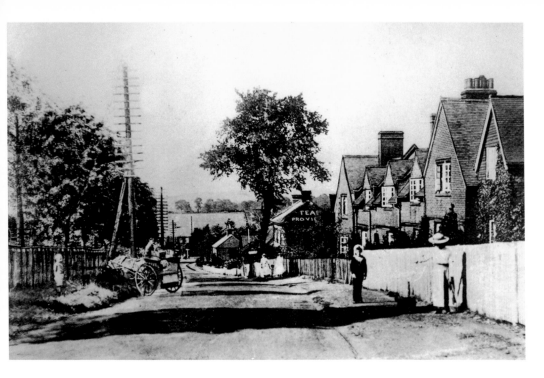

Elstree in Transition

Elstree Hill North in 1907; looking to the north along Watling Street we see the village in transition. The houses on the right, which have mostly survived, were built in the 1880s to house the workers for the Aldenham Estate.

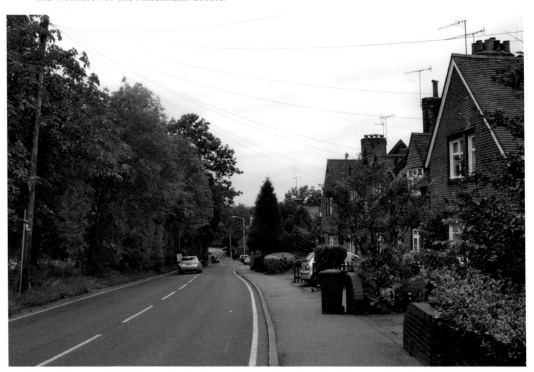

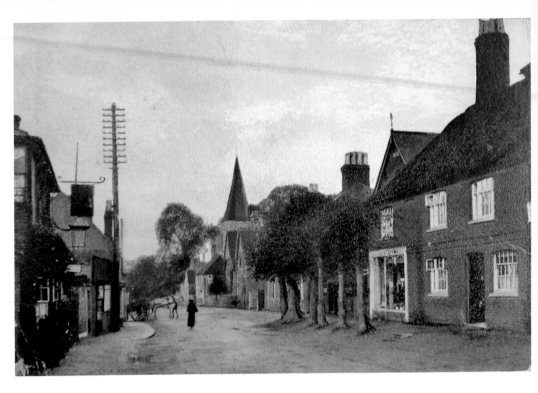

The Plough Hotel

Elstree High Street in 1911 looking to the north. The picture was taken standing outside the Plough Hotel, which is now a Chinese restaurant called The East. Structurally it is still very much as it was at that time.

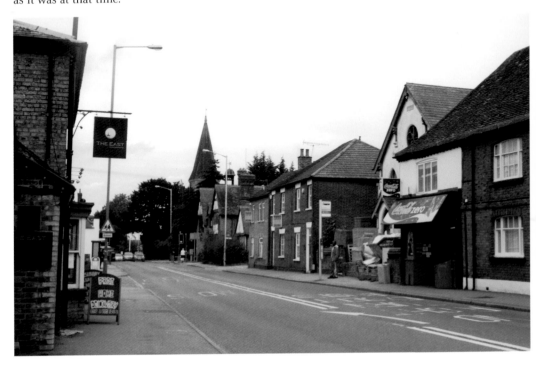

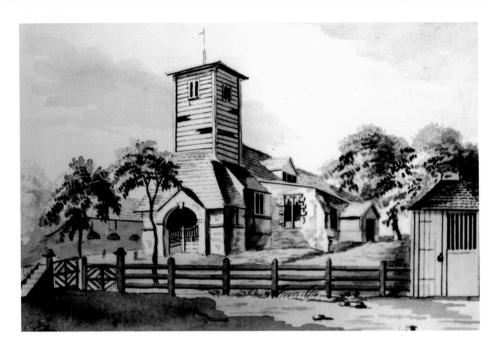

St Nicholas Church

This drawing of St Nicholas Church from around 1790 shows the church prior to its restoration in 1853. A local directory of 1832 describes it as a 'mean building without anything in its interior worthy of notice'. Of particular interest is the village lock-up. On the other side of the church were the stocks, not visible in this drawing. The postcard below dates from 1903 and shows how the church transitioned from a 'mean building' to a respectable Victorian place of prayer.

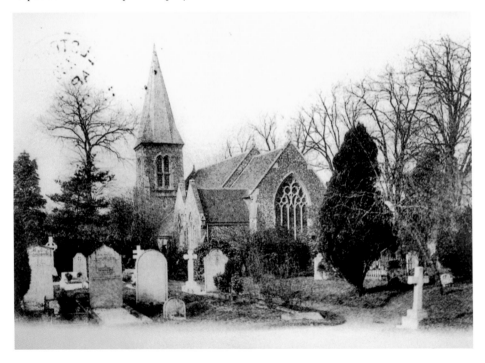

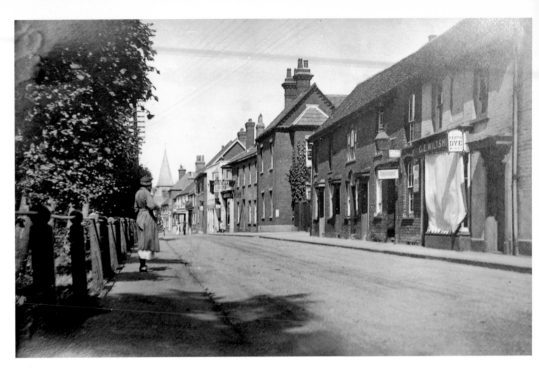

The Crossroads

This picture from around 1920 was taken from the south side of the crossroads, about 200 yards before the present day junction.

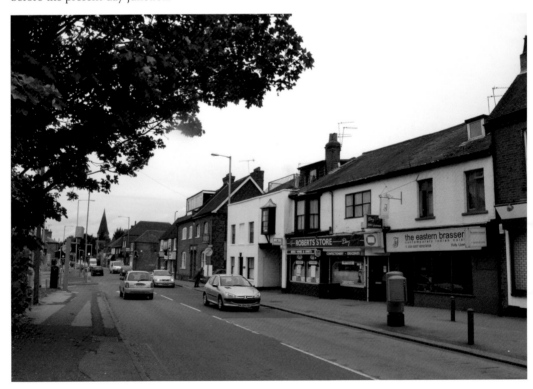

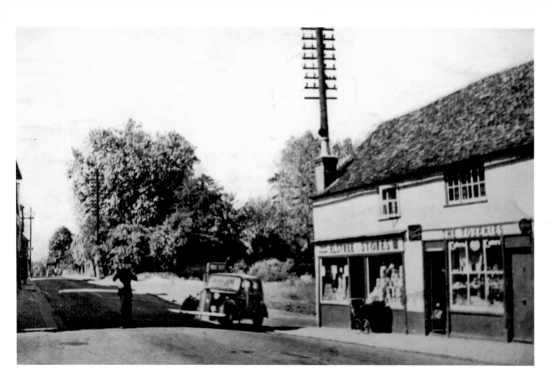

Stanmore Hill

This picture, also dating from the 1920s shows the reverse view of the previous picture looking to the south towards Stanmore Hill. The Elstree Stores and its neighbour to the right were demolished in the 1920s to widen the crossroads. This left the Plough on the corner, as it still is.

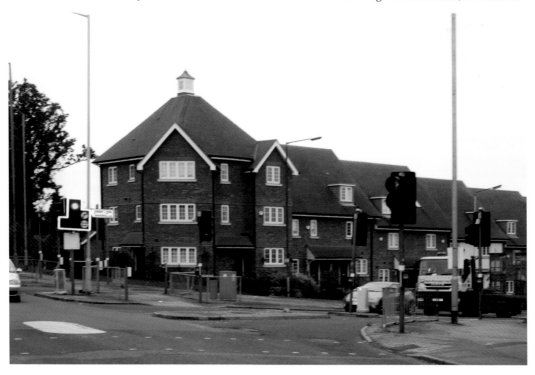

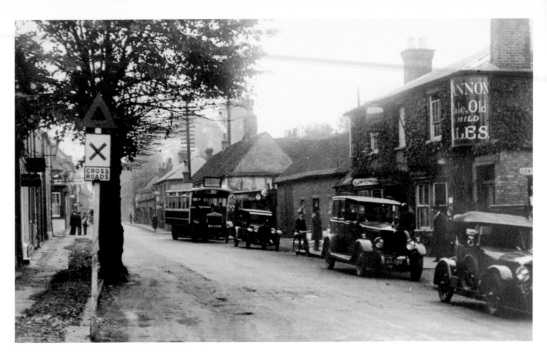

Elstree Buses

Elstree High Street *c.* 1924 with buses and cars waiting outside the Plough, now The East. A bus service which ran from Watford to Enfield via Elstree commenced in 1922. It went by way of Elstree High Street, Allum Lane, Shenley Road and Furzehill Road.

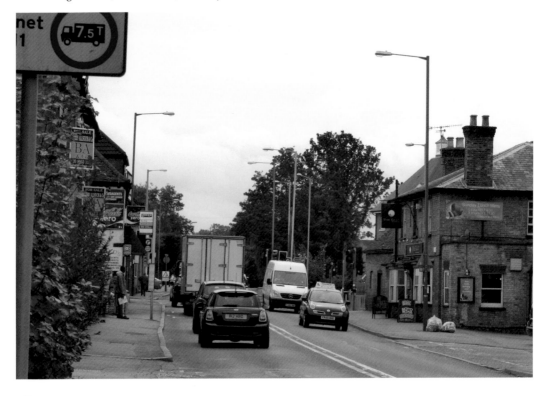

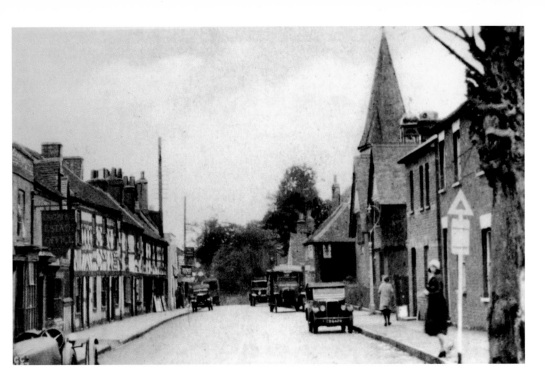

The National School

By 1935 the High Street is losing its rural feel. The Tudor buildings on the left of the picture fell victim to development, as the modern photograph shows. The National School and St Nicholas church are on the right.

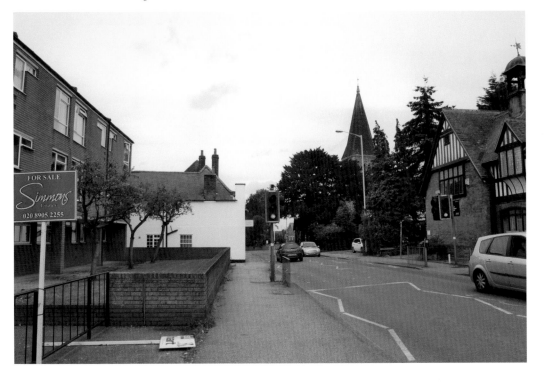

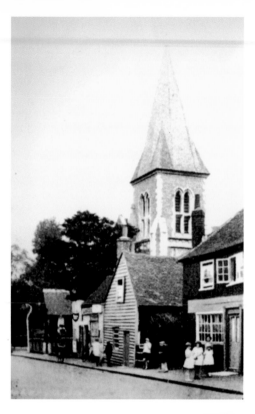

Changing Elstree
This picture, taken in 1930 shows two seventeenth-century cottages on the right, which were demolished in 1955/6. There are two modern houses on the site.

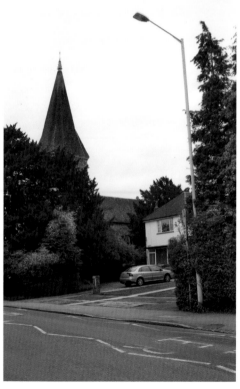

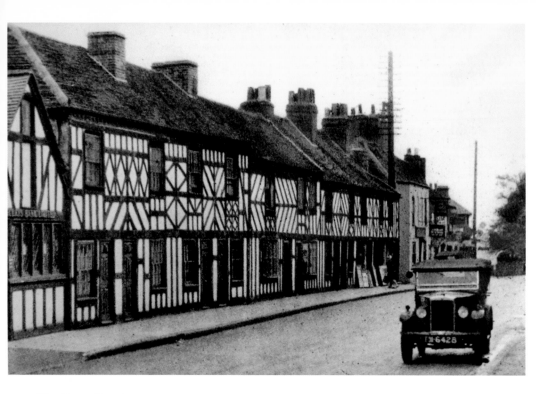

The Green Dragon

This picture taken from Elstree Hill North, looking to the north, shows the Green Dragon public house on the left. This was demolished and replaced with the buildings seen in the 2011 photograph.

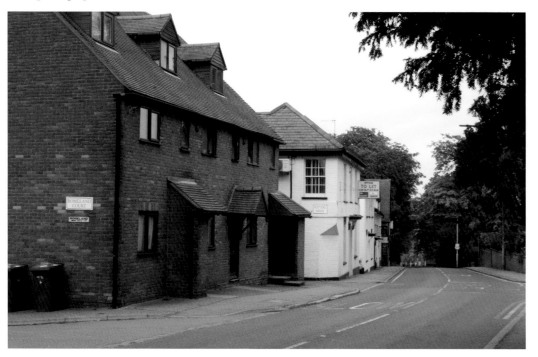

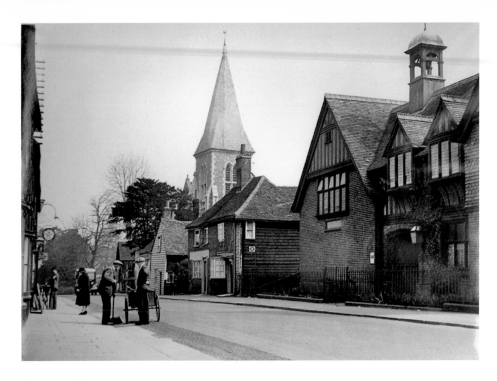

Elstree at War

Elstree High Street in 1939, on the eve of war. The National School, now a synagogue, is on the right. The two cottages have since been replaced by modern buildings. In 1935 Parliament authorised the extension of the Northern Line Tube to Elstree. There was much local opposition for fear of destroying the rural character of the area. Happily for them, the outbreak of war meant the shelving of the project.

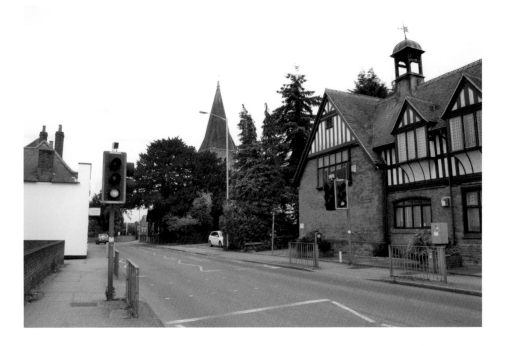

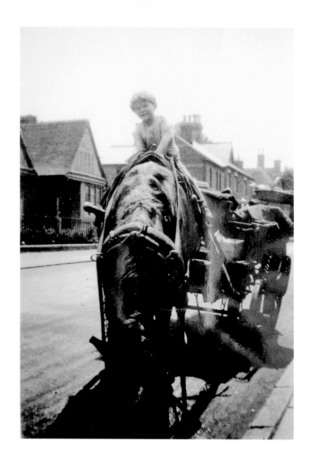

The Almshouses
A horse and cart in the High Street, *c.* 1925. Behind the horse, to the left, can be seen the Almshouses built by Henry Hucks Gibbs of Aldenham House in 1883. They still stand, but appear neglected.

43

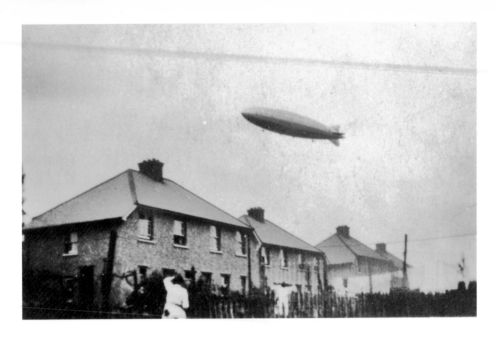

The *R101* Airship

The *R101* Airship, a British Air Ministry project that commenced in October 1929. Only one was built. It crashed in France during its maiden overseas voyage on 5 October 1930. Forty-eight of the fifty-four people on board were killed including Lord Thomson, the Air Minister who had initiated the programme. The loss of *R101* was one of the worst airship accidents of the 1930s. This photograph shows the *R101* in 1930 passing over the corner of Watling Street and Allum Lane.

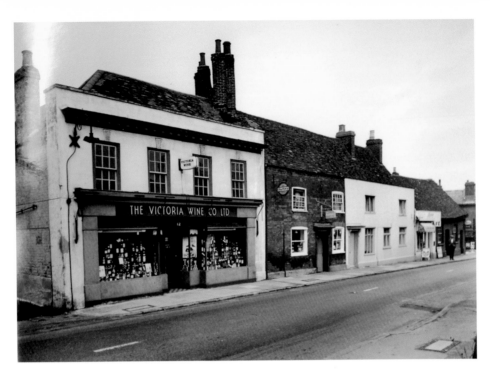

12–16 High Street
Numbers 12–16 High Street Elstree in 1964. As can be seen from the modern photograph, the building still remains.

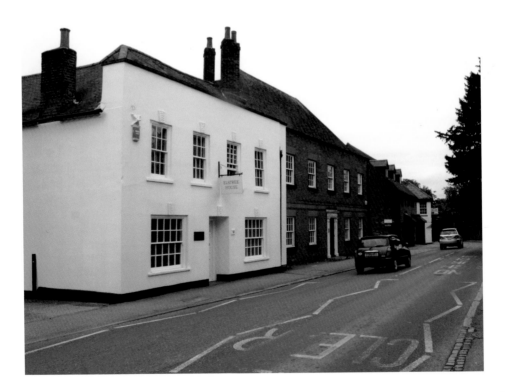

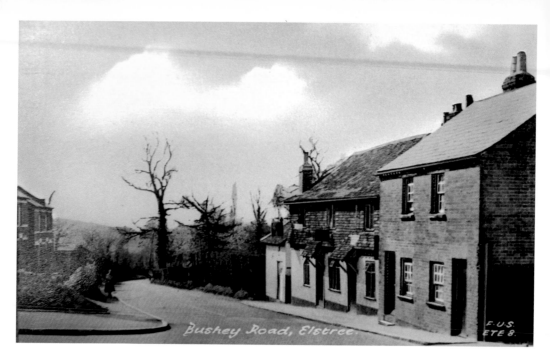

Bushey Road, Elstree.

F.U.S.
ETE 8.

The Farmer's Boy

The Farmer's Boy public house in 1958. It stood on the corner of Elstree High Street and the Watford Road. Built originally as a private dwelling in the eighteenth century, it became a pub in around 1900. It was demolished in 1967 when the road was widened. The modern photograph shows where the pub formerly stood.

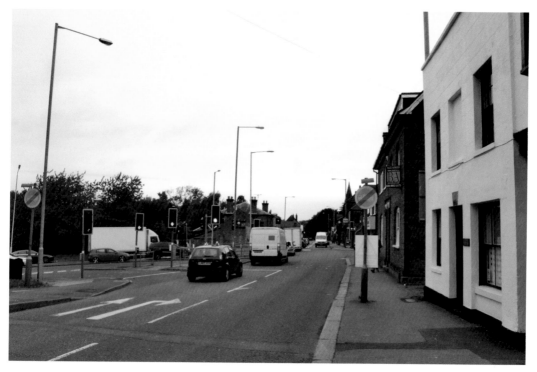

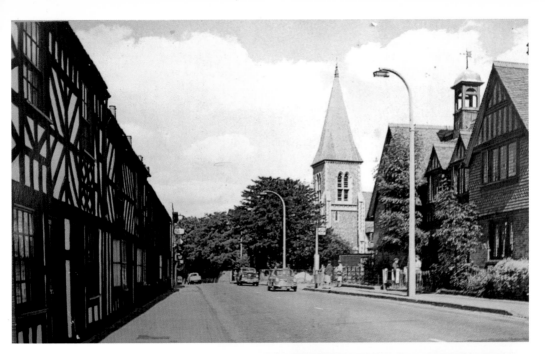

The High Street

The high street in 1964. The Tudor buildings on the left no longer stand, and street lighting has arrived. The picture above looks from south to north along Watling Street, which runs through the centre of the village. The picture below shows the old police station, still standing near the corner of the High Street and Barnet Lane.

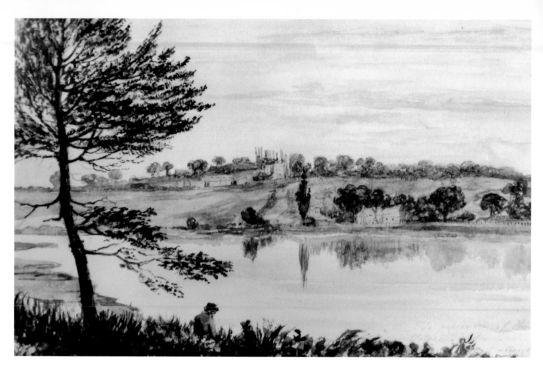

Elstree Reservoir

This is a drawing of Elstree Reservoir, now known as Aldenham Reservoir. It dates from May 1822. The exact spot that the artist stood on looking towards Elstree village can still be located in Aldenham Country Park, next to the car park.

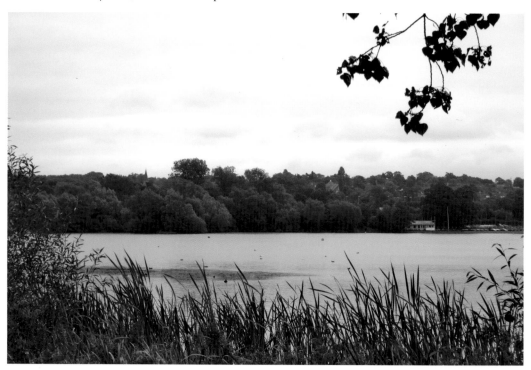

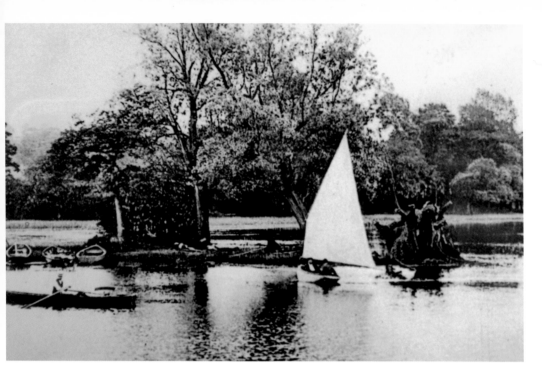

Elstree Reservoir
Aldenham Reservoir, originally Elstree Reservoir, was constructed by an Act of Parliament dated 1793. It was built on what was originally Aldenham Common. It was popular for boating and fishing. Charles Dickens often visited his friend William Macready (1793–1873), who lived nearby, and rowed on the lake. This photograph was taken around 1905.

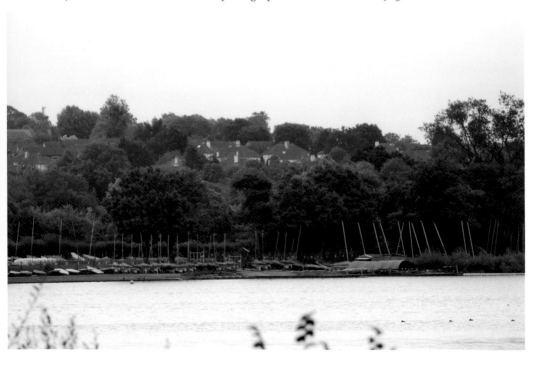

Elm Place

The junction of Watford Road and Aldenham Road *c.* 1905. Charles Dickens often stayed with his William Macready, who lived at Elm Place for nine years from 1831. Elm Place no longer stands, but was located on the corner to the right of the pictures.

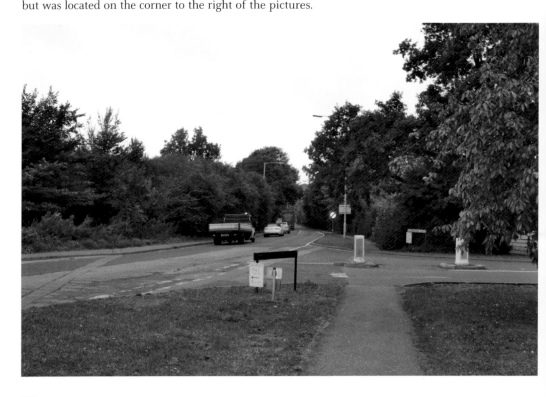

St Nicholas Church

Elstree St Nicholas church, from a drawing *c.* 1790. Situated in the heart of Elstree High Street, it dates from 1188, the south doorway was made in 1460 and displays the rose of Henry VI. The stone font dates from the fifteenth century. A number of well-known Victorians made use of this font, including Charles Dickens, and Sir Richard Burton, the future explorer who was born at nearby Barham Hall. Martha Ray is buried here. Born in Elstree in 1746 she was the daughter of a local labourer. At sixteen she became a singer at Covent Garden Theatre where she attracted the Earl of Sandwich, to whom she bore several children. She also attracted the attention of an admirer, James Hackman, whom she rejected. As she left the theatre, on the evening of 14 April 1779, Hackman shot her through the head. He was executed five days later at Tyburn. Martha Ray was buried in a vault under a pew in St Nicholas church, alongside her mother. Rediscovered during renovation in 1824 she was moved to an unmarked grave in the churchyard. In 1920 the then earl of Sandwich had a tombstone erected over her grave. It is still there, near the footpath.

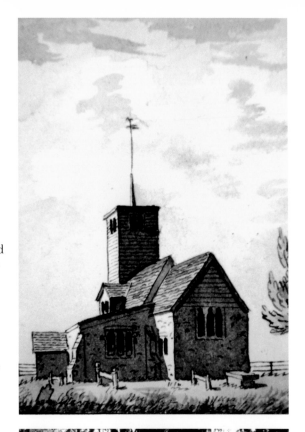

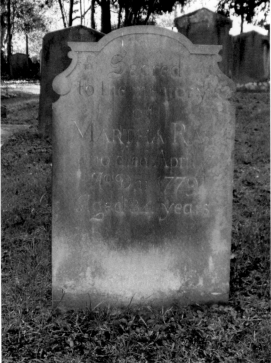

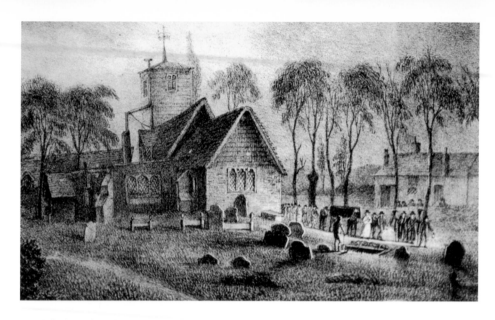

St Nicholas Church Weare Burial

This contemporary illustration shows the burial of murder victim William Weare in 1823. *The Times* of 2 November 1823 comments 'Shortly before 11 o'clock, the tolling of the church bell announced everything was prepared for the melancholy ceremony ... a considerable crowd proceeded up Elstree-hill towards the church (from the Artichoke) ... the coffin was. first carried into the church which was lighted up for the occasion ... as the coffin was being lowered into the grave, the rope ... broke [and] the coffin fell suddenly to the bottom of the grave ... the sexton immediately descended into the grave, and by great personal exertion, in a short time succeeded in getting the coffin level at the bottom of the grave...' The article describes the atmosphere surrounding the night-time funeral: 'The solemn stillness of the night, for the wind which had been loud and boisterous during the day, had now fallen, and did not even shake the branches of the high trees with which the churchyard is surrounded – The service being finished at about half-past eleven, the mourners retired from the church yard and the grave diggers proceeded to fill up the grave.'

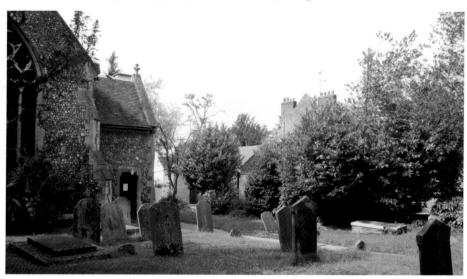

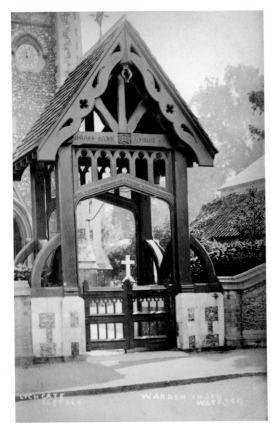

Edgewarebury

The lych-gate was donated by Sir Arthur Trevor-Dawson, First Lord of the Admiralty who lived at nearby Edgewarebury, off Barnet Lane. Edgewarebury is now a hotel. The old photograph dates from 1909.

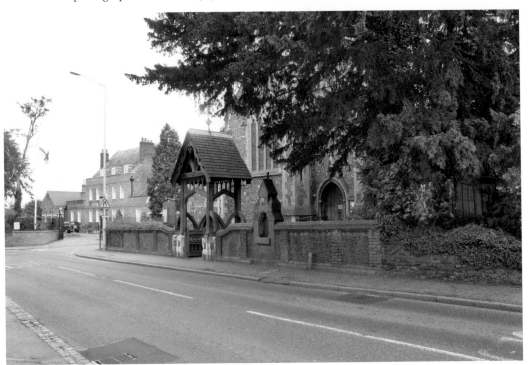

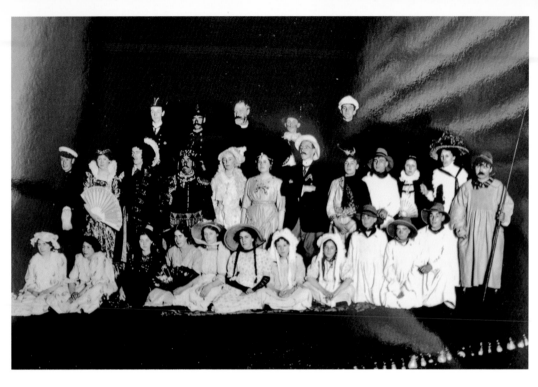

St Nicholas Church Group
The St Nicholas Church Group performing Gilbert and Sullivan, between 1910 and 1912.

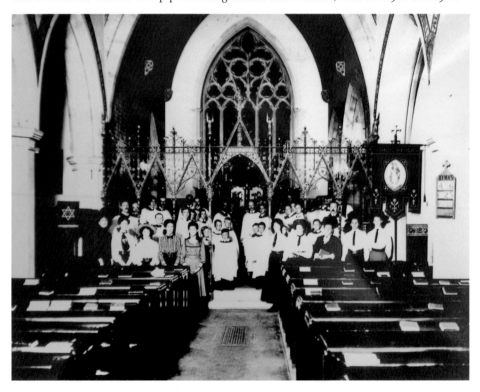

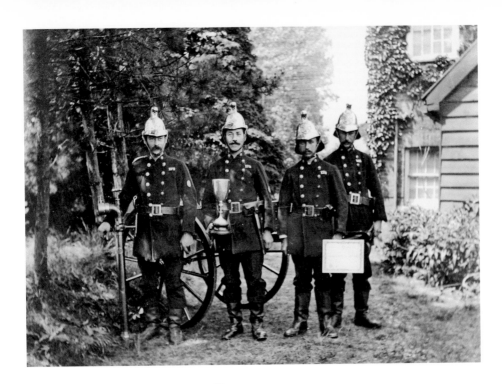

Elstree Fire Brigade and Post Office

Above, Elstree fire brigade, c. 1910. Elstree and Borehamwood were both reliant on an engine kept at Wellington & Ward in Borehamwood, and a machine kept at Elstree Preparatory School in Elstree Hill South. The building is now a nursing home. Below, the post office in Elstree High Street, c. 1910. A post office is listed as being in the 'main street' by a directory of 1839. Letters posted in London reached Elstree the same day and were delivered at 3 p.m. and 7 p.m.

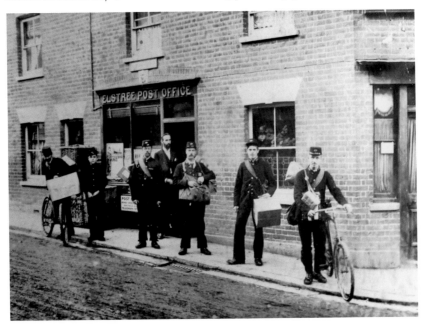

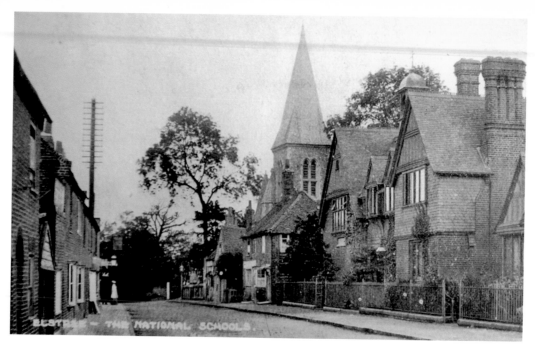

Elstree School

The first school in Elstree was set up in 1814 next to the Artichoke public house, near the corner of Allum Lane. In 1884 the school moved to a new purpose-built site, opened by the Bishop of St Albans on 28 April. By 1898 it tutored eighty-five boys and girls as well as fifty-five infants.

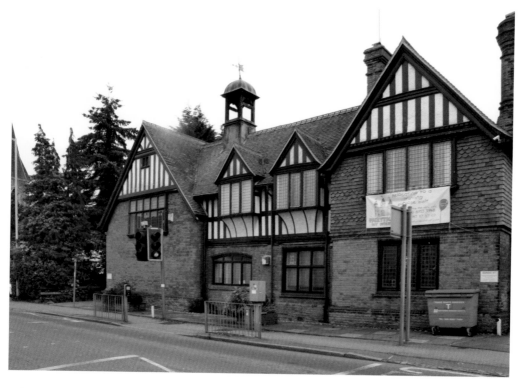

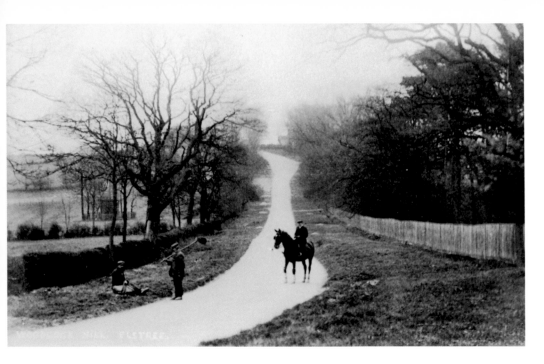

Barnet Lane

The old photograph, *c.* 1905, shows Woodcock Hill, Barnet Lane, with Deacon's Hill behind the photographer. To the centre left of the photograph can be seen the railway tunnel vents, which still remain.

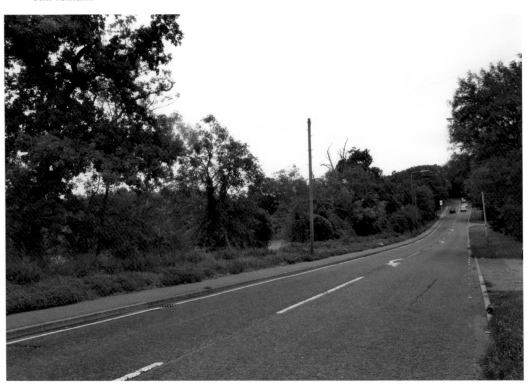

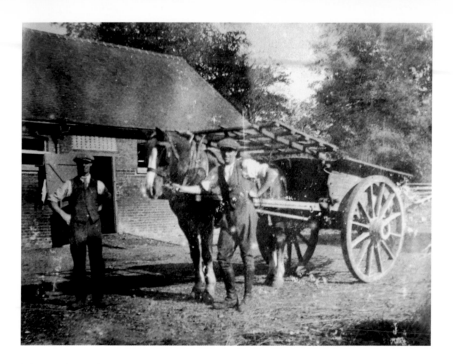

Edgwarebury Farm
This photograph of workers on Edgwarebury Farm was taken in the 1920s. The picture below shows what is now the Edgwarebury Hotel, which during the latter part of the nineteenth century was the home of Sir Arthur Trevor-Dawson, First Lord of the Admiralty, and his family.

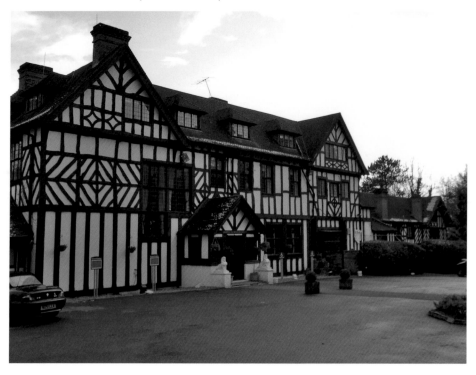

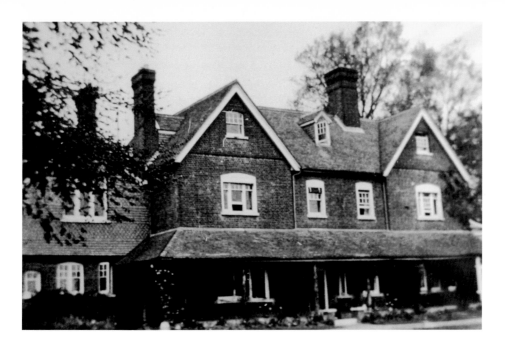

Abbots Mead

Abbots Mead in Barnet Lane. In the 1950s and 1960s this was the home of the family of Simon Cowell. It was then bought by Stanley Kubrick who lived here until the 1980s. The photograph dates from 1915. Below we see Barnet Lane c. 1910. The road was popular with the film stars that frequented the nearby film studios. Friars Mead along here was purchased by Joan Collins and Anthony Newley, and the nearby Chantry was rented by film studios for their more transitory stars.

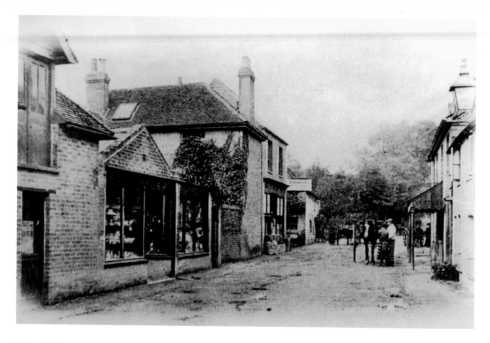

Theobald Street

Theobald Street looking to the north, *c.* 1903. The station is directly behind the photographer. This was originally the centre of Borehamwood, but after the arrival of the railway and the development of the film industry Shenley Road developed rapidly and took its place. From the modern photograph it is evident that extensive redevelopment has taken place in the vicinity of the station.

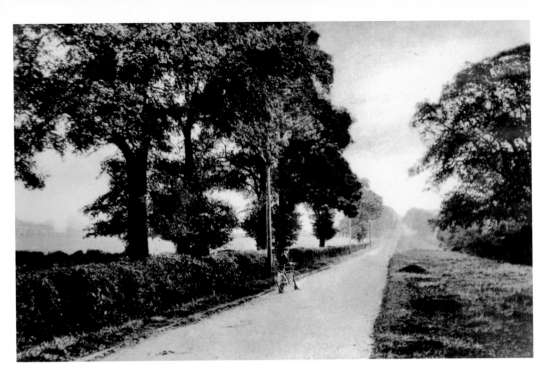

Furzehill Road
Furzehill Road looking to the south east. The old picture dates from around 1903.

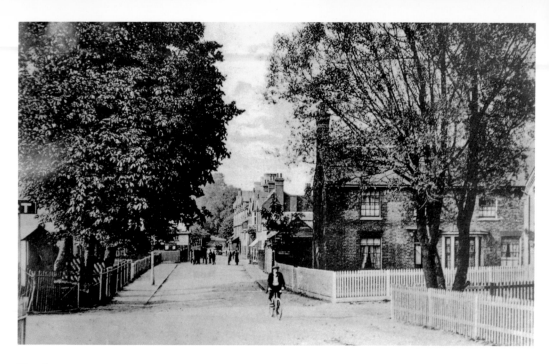

The Crown

The Crown in Theobald Street Road looking towards Radlett. The stable block is all that survives. The original building was first mentioned in the record in 1760. The modern picture shows all that remains o the old building. On the right of the old photograph can be seen the old village pound. By 1911 the total population of Borehamwood was 1,527. The picture dates from around 1905.

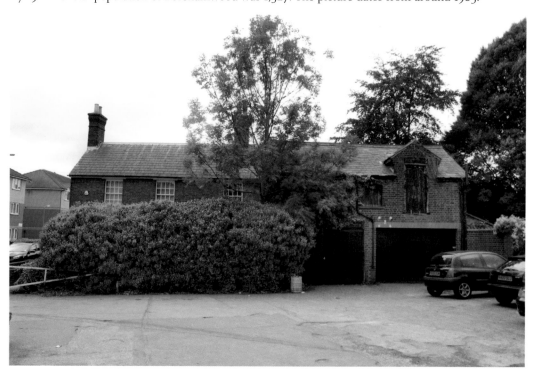

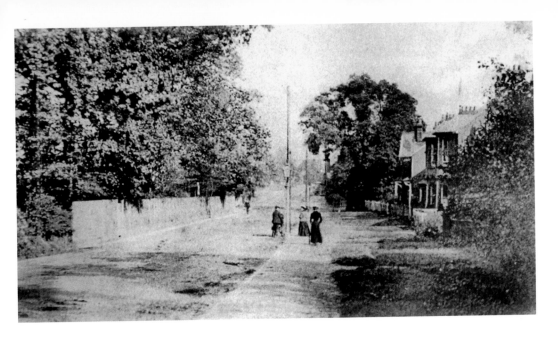

Shenley Road
Shenley Road view to the east. Glenhaven House stood behind the hedges on the left. The picture dates from 1903.

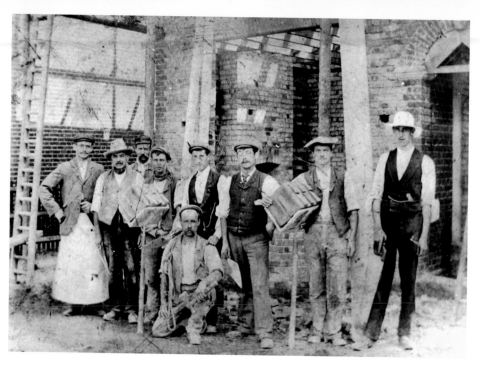

Shenley Road and Wellington Ward

The picture above, dated 1903, shows builders in Shenley Road. It reflects the increasing amount of development in Shenley Road. Below are the premises of Wellington & Ward. They made photographic paper. Between 1900 and the late 1920s they were the biggest employer in Borehamwood. It was located north of Shenley Road near where the Boulevard is now located. The picture dates from 1905.

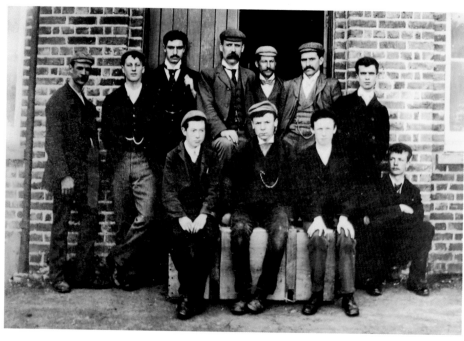

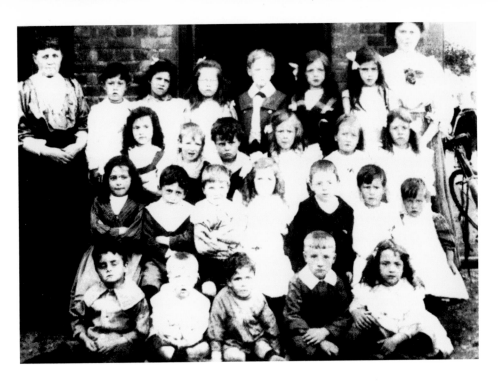

Borehamwood Schools

Children from Borehamwood's first school at 73 Theobald Street, which came into being around 1870. This building, still standing, is another school located a few yards away from the original – down a small alley opposite the Wellington public house – and dates from 1896. It was shut down in 1917 due to expansion, and the pupils relocated.

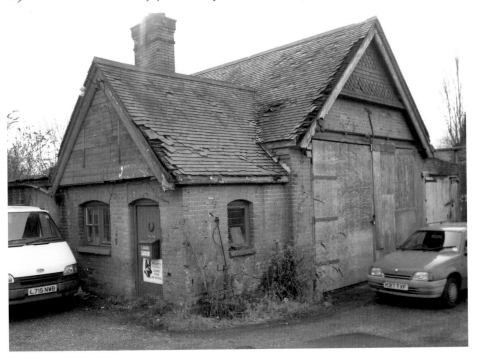

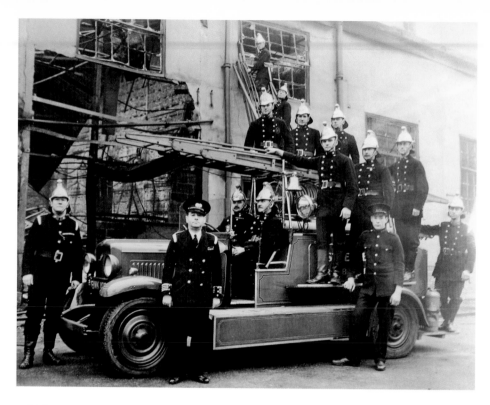

British International Pictures

The BIP Fire Brigade, after the fire at British and Dominions Studio, February 1936. The Studios opened in 1925 and were the first purpose-built sound studios in Europe. The fire ended a short but eminent existence. Imperial Place near The Venue is where BIP once stood.

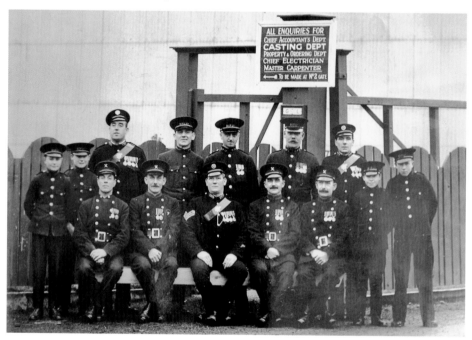

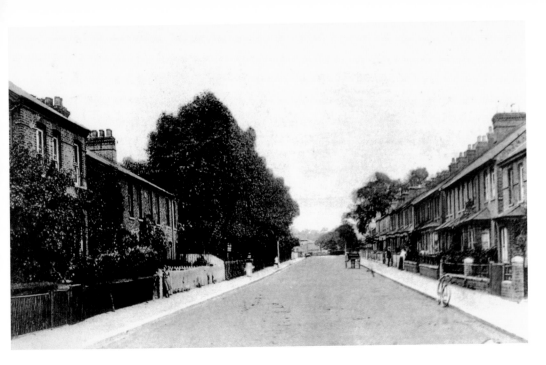

Drayton Road

Drayton Road in 1903. The road is now a heavily developed adjunct to Shenley Road and is the home of both the *Borehamwood and Elstree Times* offices and the Elstree and Borehamwood Museum. The museum, a treasure trove of local history, opened in November 2000 and is well worth a visit.

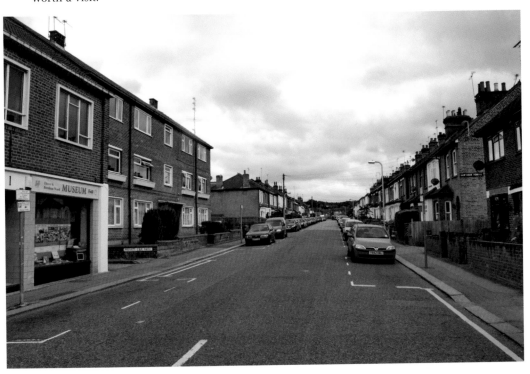

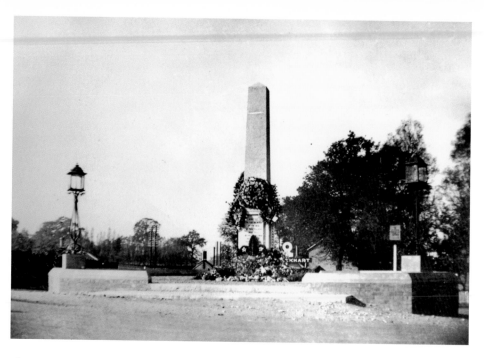

The War Memorial

The Borehamwood war memorial *c.* 1921. This First World War memorial was dedicated shortly after the memorial in Elstree village, on 20 October 1921. It stood near the Crown public house on the corner of Theobald Street and Shenley Road. Shortly afterwards it was moved to the end of Shenley Road near the Hertsmere civic offices.

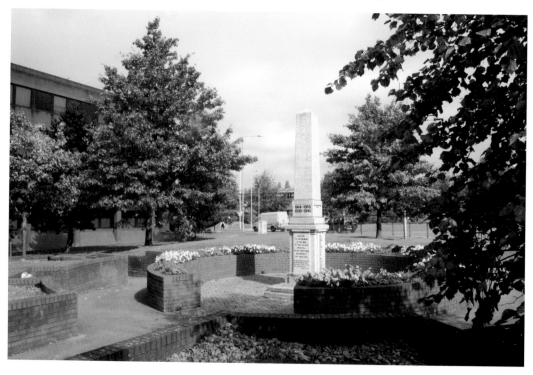

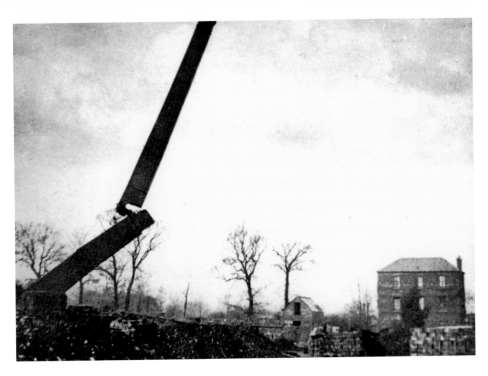

Brickfields

The demolition of Brickfields Chimney in 1916. It was regarded as being a target for German Zeppelins. The brick and tile works which had just shut down were located near Elstree & Borehamwood railway station. The entrances were next to each other.

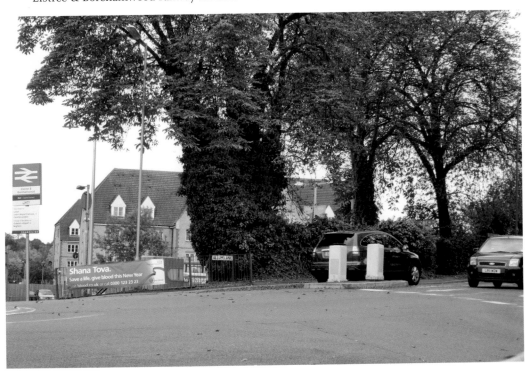

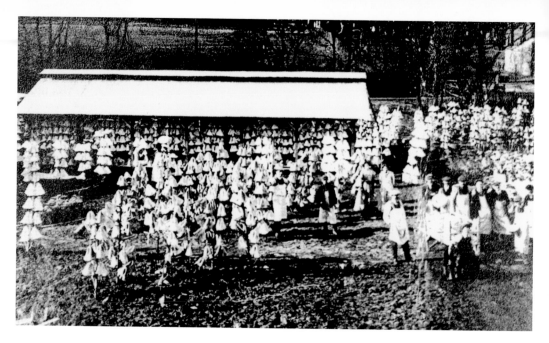

Business in Borehamwood

The Panama Hat manufacturing company was situated on the north side of Shenley Road and flourished between 1908 and 1925. The Boulevard shopping centre sits immediately to the north of Shenley Road and shows how much business has developed in Borehamwood in the last sixty years.

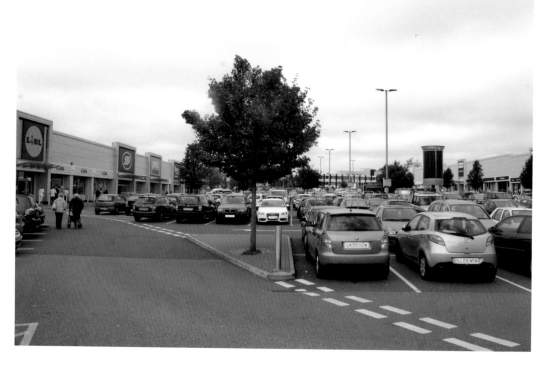

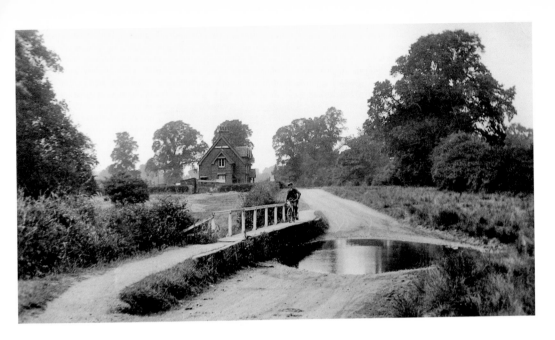

The Watersplash

The watersplash was a feature of Theobald Street until a bridge was built over it in the 1920s. A local author commented that as a child 'when the floods were out, children would hasten to the one between Tykes Water and Organ Hall Farm, take their stand on a high rickety foot-bridge, and watch cars and motor bikes endeavour to get through the swollen stream, and to their huge delight, stall in the middle.'

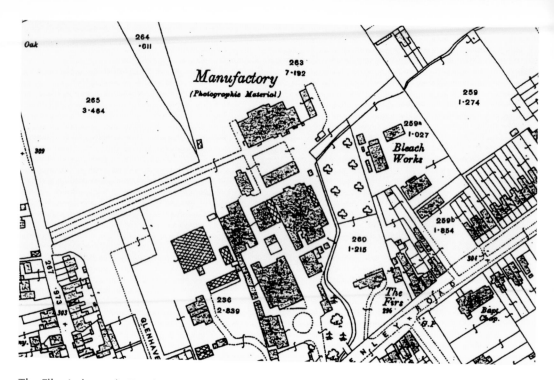

The Film Industry in Borehamwood

Borehamwood, 1914. Development is underway as can be seen in the 1914 Ordnance Survey. By 1934 Borehamwood is becoming a focus for the film industry and associated business.

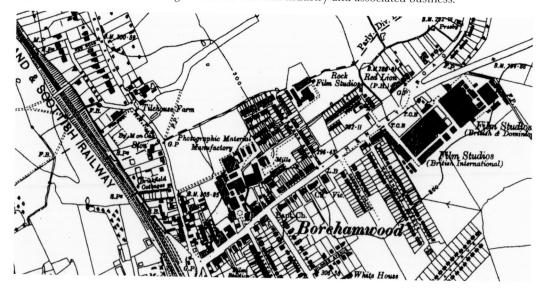

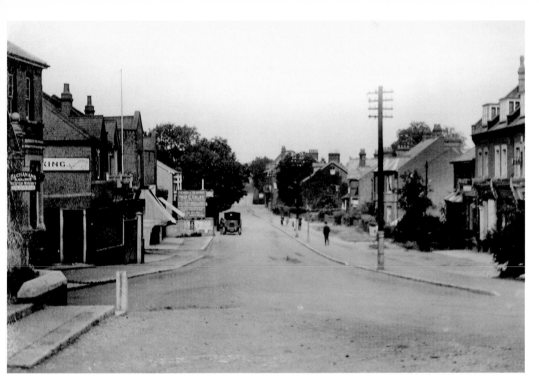

Station Parade
Station Parade, part of Shenley Road looking towards Elstree Station, which is hidden, but in the distance to the left. This picture was taken around 1925.

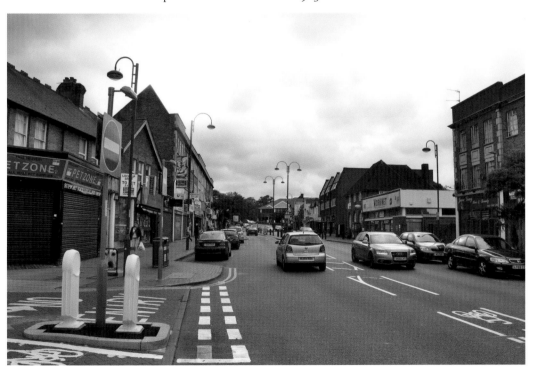

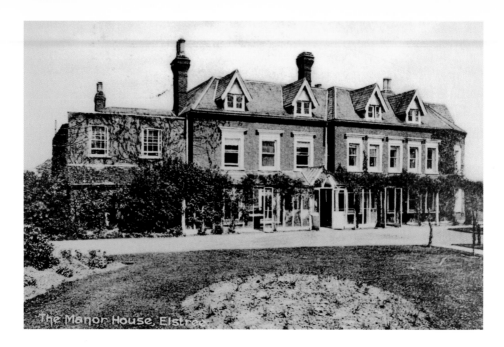

Allum Hall

Allum Hall, formerly The Manor House. The building was originally a manor house dating back to the seventeenth century. The house and entrance cottage Manor Lodge remain within the form of later eighteenth- and nineteenth-century structures. The Hall now houses the Citizens' Advice Bureau and hosts functions. It is situated almost opposite Elstree & Borehamwood Station at the junction of Allum Lane and Deacon's Hill Road. The photograph dates from around 1904.

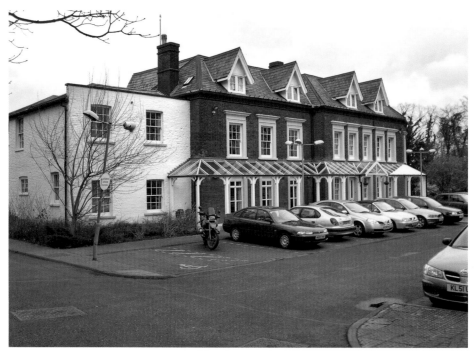

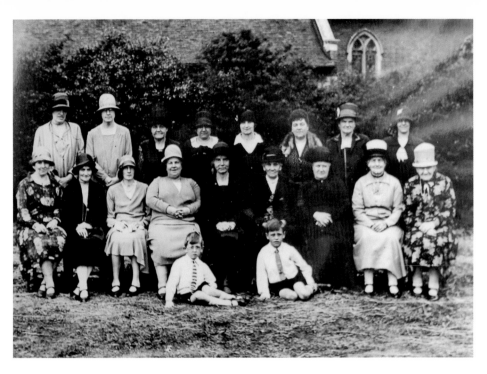

All Saints Church Working Party
All Saints church working party *c.* 1930. All Saints, Shenley Road was built in 1909 to cater for the growing population of Borehamwood. The tower was added in 1957.

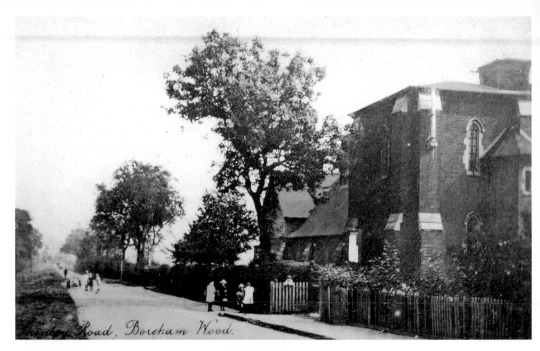

Shenley Road, Boreham Wood.

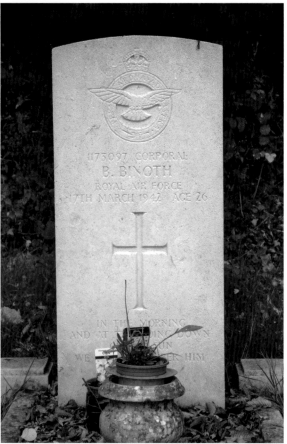

All Saints Church

This picture of All Saints church dates from 1920. The Church remains now in much busier surroundings. Shenley Road is now the centre of Borehamwood. Behind the church is the graveyard. In the graveyard is a sad reminder of the Second World War, the grave of Corporal B. Binoth of the Royal Air Force who died in March 1942 at the age of twenty-six.

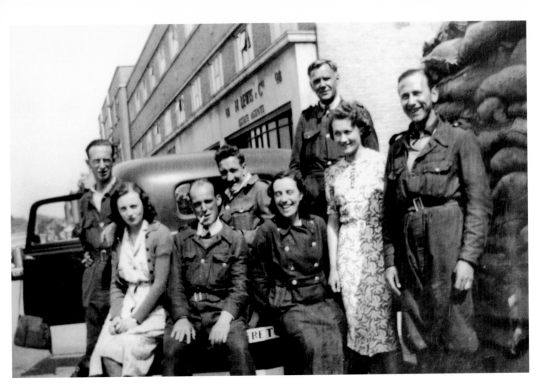

Village Hall
This picture taken outside the village hall dates from 1940/41. The hall has survived the redevelopment of Shenley Road and is often used to host antique fairs.

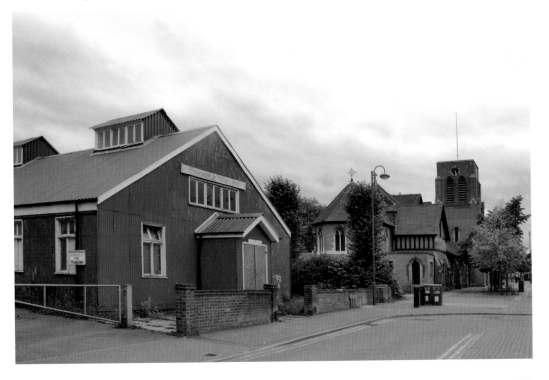

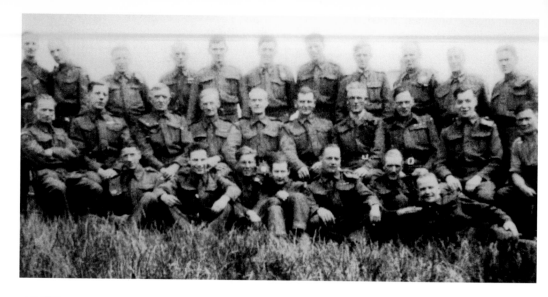

Wartime

Above we see the Borehamwood regiment of the Home Guard. There was a Polish army camp in Theobald Street near to Chatsworth Close. A German POW camp was situated near the gasworks in Station Road. Below, shelter practice at the Keystone works in Borehamwood. Elstree and Borehamwood were struck by bombs a number of times during the war. A bomb fell on Allum Lane outside Nicholl Farm on 5 January 1940. On 27 September 1940 the Fortune, a house in Barnet Lane, was struck and four people were killed. A house on the corner of Cardinal Avenue and Hillside Avenue was destroyed by high explosive in November 1940.

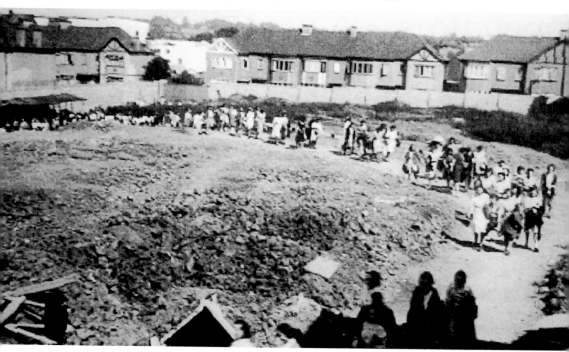

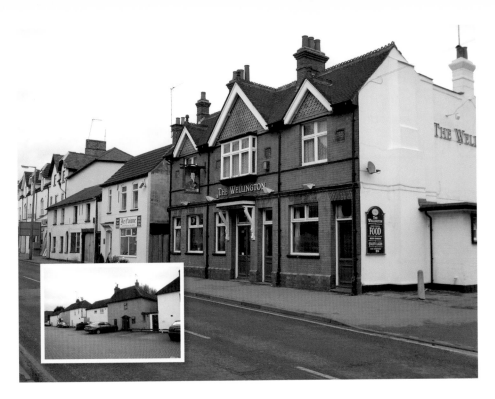

Brickfield Cottages

Theobald Street near the Wellington public house, 2005 and 2011 showing the disappearance of another of Borehamwood's early buildings. Almost opposite is Borehamwood's first school, now in poor condition, and the nineteenth-century Brickfield Cottages, a reminder of Borehamwood's past.

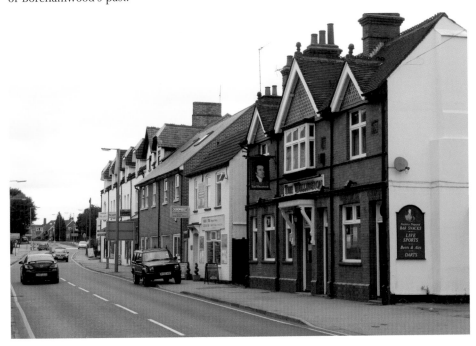

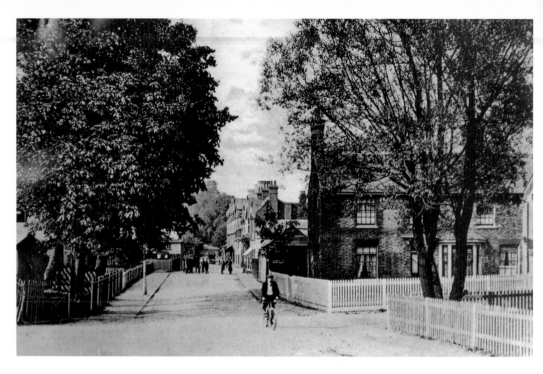

Theobald Street

Theobald Street looking to the north towards Radlett from outside Elstree & Borehamwood Station. Traces of the buildings in the 106-year-old picture can still be seen in 2011. The area of the animal pound, in the foreground to the right of the picture, is now a pub car park.

Baptist Chapel

Above, this building in Theobald Street was originally used as a school, but by 1870 had become a religious meeting house. Below, the Baptist chapel in Gasworks Lane, now Station Road. The chapel, at the entrance to Elstree & Borehamwood Station was built in 1894, and before recently becoming a flower shop, it fulfilled a sequence of functions including that of the country's smallest cinema, and later, a public convenience. It is now the only reminder of the old Elstree Station, the stationmaster's house having been recently demolished to make way for housing.

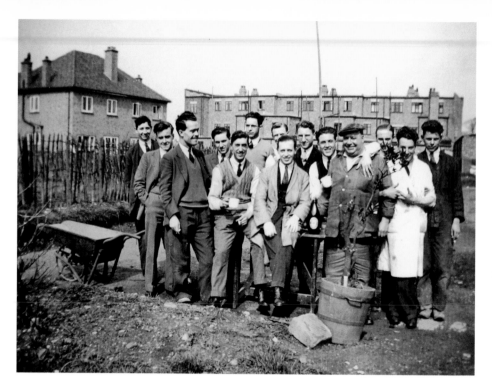

Shenley Road

These two photographs show the further development of Shenley Road. The workers above are from the Elstree Film Laboratories, which was located close to Whitehouse Avenue. This photograph dates to 1931. The lower picture dated July 1915 looks from near Glenhaven Avenue towards All Saints Church.

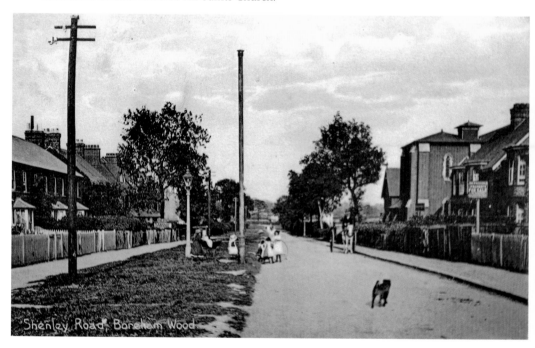

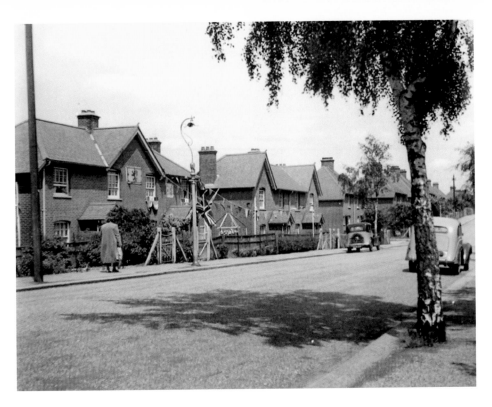

Coronation of Elizabeth II
The photograph shows coronation decorations in 1953 in Hillside Avenue.

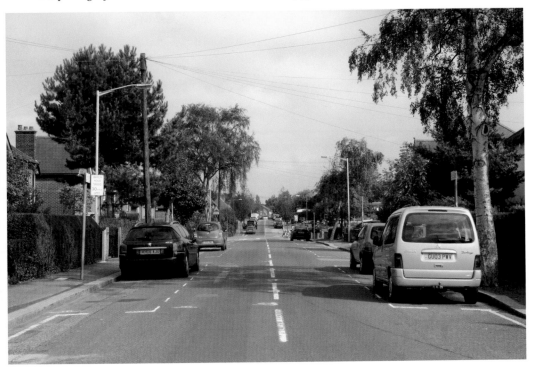

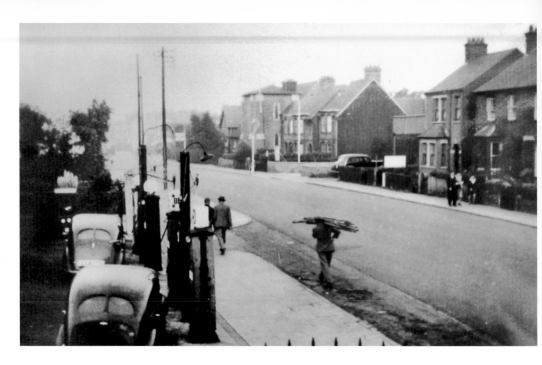

Views from Shenley Road

These two pictures date from the beginning of the 1950s. The upper picture looks from a petrol station in Shenley Road towards All Saints Church. The lower picture looks towards Elstree Station. Many of the buildings still remain, including the old post office building on the right.

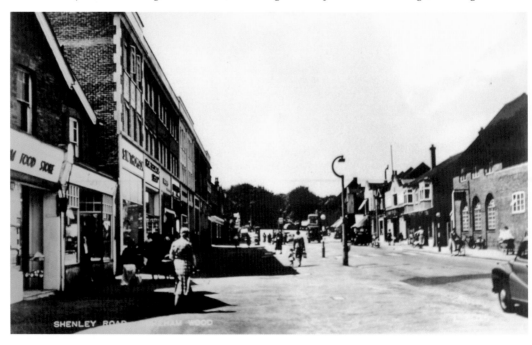

SHENLEY ROAD

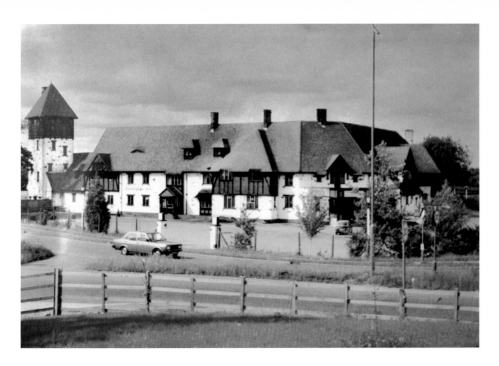

The Thatched Barn

The Thatched Barn was a noticeable signpost for Borehamwood being situated directly on the A1, It was a mock-Tudor hotel built in the 1930s Many film stars from the nearby studios stayed here. At one time it was a holiday camp run by Billy Butlin, before being requisitioned as Station XV by the Special Operations Executive (SOE) in the Second World War, and used to train spies. The original building was torn down at the end of the 1980s, and replaced ultimately by a Holiday Inn hotel.

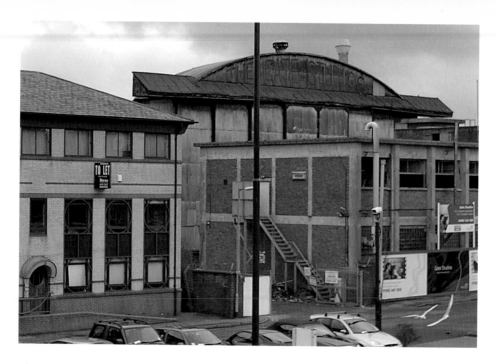

The Gate Studios

The Gate Studios, built 1928, were situated to the left of the forecourt of Elstree & Borehamwood Station. Being the era of silent movies, train noise was not a problem. With the arrival of sound, a crow's nest was built on the roof with a buzzer where a runner would sit perched with a pair of binoculars to warn of trains. The unit was finally demolished in February 2006 to make way for a block of flats.

Film Heritage

In 2011 no trace remains of the Gate Studios. To the left can be seen the former Gem Cinema, at one time Britain's smallest cinema, and now a flower shop. Below can be seen a reminder of Elstree's film heritage in the station car park.

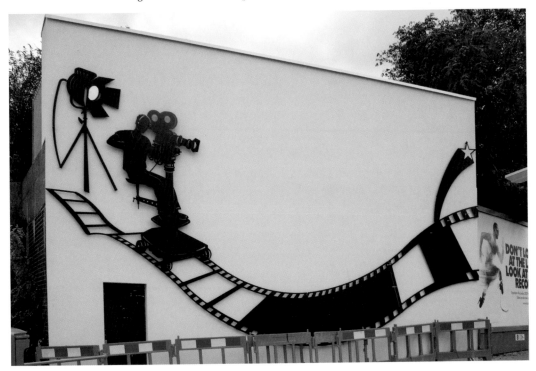

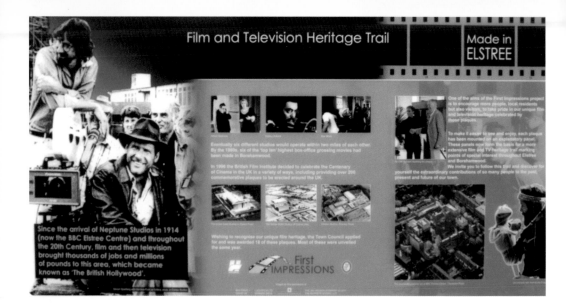

Film Heritage

This plaque in Elstree & Borehamwood Station forecourt is one of eighteen plaques spread throughout Borehamwood informing visitors of the areas film and television heritage. The McDonald's in Shenley Road is situated in the immediate vicinity of the Elstree Film Studios. In its former incarnation as the Red Lion it played host to many early stars, including Tony Hancock and Errol Flynn.

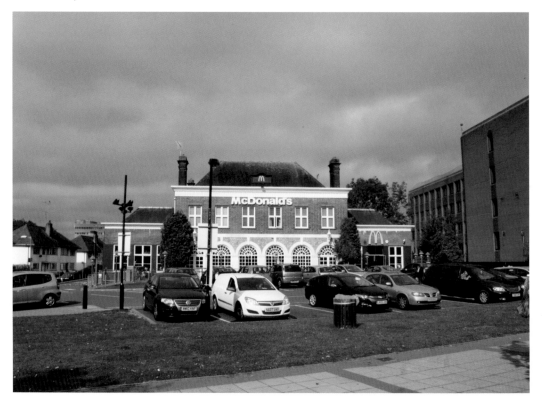

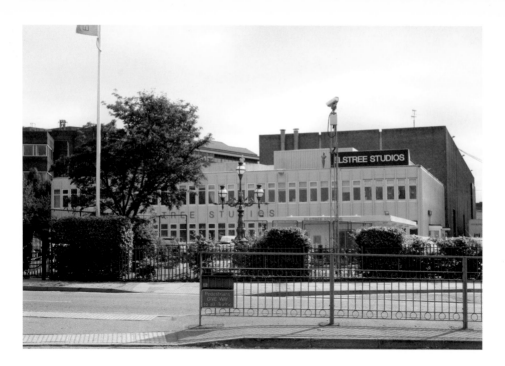

Elstree Studios

Elstree Studios opened in Shenley Road in the 1920s. A number of classic films were created here including *The Dam Busters* and *Moby Dick*. Stars that used this studio included Errol Flynn, David Niven, Ronald Reagan and Richard Attenborough. In the 1960s the studios expanded into television producing *The Avengers* and *The Saint*. Probably the best known production at Elstree Studios was George Lucas' *Star Wars*. The studios, now known as the Elstree Film and Television Studios has played host to *Who Wants to be a Millionaire?* and *Big Brother*.

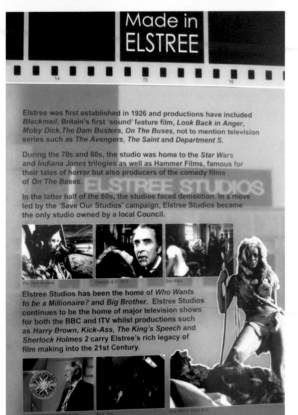

Made in ELSTREE

Elstree was first established in 1926 and productions have included *Blackmail*, Britain's first 'sound' feature film, *Look Back in Anger*, *Moby Dick*, *The Dam Busters*, *On The Buses*, not to mention television series such as *The Avengers*, *The Saint* and *Department S*.

During the 70s and 80s, the studio was home to the *Star Wars* and *Indiana Jones* trilogies as well as Hammer Films, famous for their tales of horror but also producers of the comedy films of *On The Buses*.

In the latter half of the 80s, the studios faced demolition. In a move led by the 'Save Our Studios' campaign, Elstree Studios became the only studio owned by a local Council.

Elstree Studios has been the home of *Who Wants to be a Millionaire?* and *Big Brother*. Elstree Studios continues to be the home of major television shows for both the BBC and ITV whilst productions such as *Harry Brown*, *Kick-Ass*, *The King's Speech* and *Sherlock Holmes 2* carry Elstree's rich legacy of film making into the 21st Century.

Elstree Studios
The plaque above is one of three outside the Elstree Film Studios details the history of the studios observing that '*The King's Speech* and *Sherlock Holmes 2* carry Elstree's rich legacy of film making into the twenty-first century.' The George Lucas sound set as viewed from the Tesco car park; *Star Wars* and two sequels were produced here. Steven Spielberg came here to direct the *Indiana Jones* trilogy.

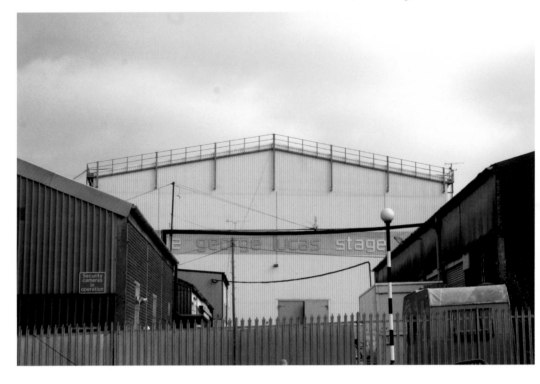

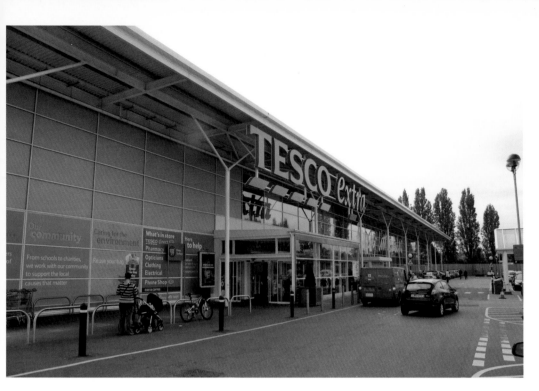

Elstree and BIP

The Borehamwood Tesco sits on land sold off when Elstree Studios was going through financial difficulty in 1990. *Star Wars* was filmed somewhere in the vicinity of the frozen food aisles! Imperial Place near the Civic Offices stands on the site of what was British International Pictures. The studios were totally destroyed by fire in 1936, despite having their own fire brigade.

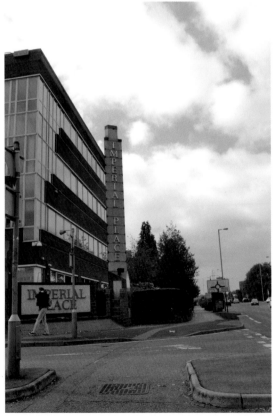

Rural Borehamwood

The photograph at the bottom gives us an idea of how rural the area around Borehamwood was around 1912. Off of the main thoroughfares surprisingly little has changed. Allum Lane leading into Shenley Road and Theobald Street has changed surprisingly little. Much remains as open fields and farmland between Borehamwood, Elstree and Radlett to the north.

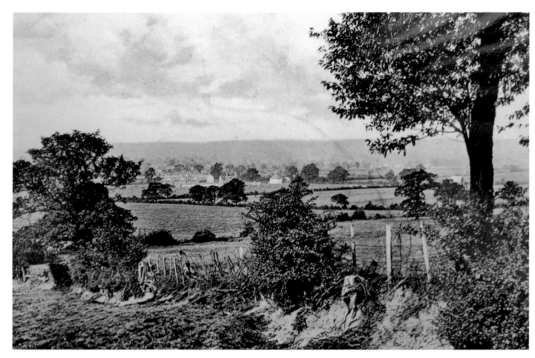

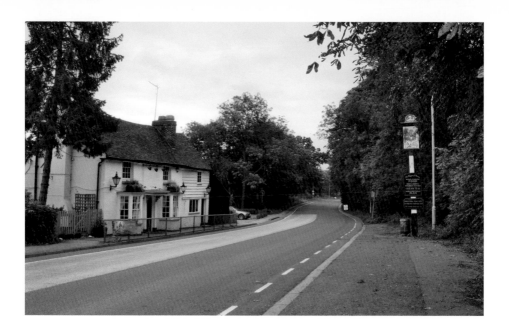

Watling Street Landmarks

The Waggon and Horses is located on Watling Street between Elstree and Radlett. The building dates from 1471 and was converted into a pub around the year 1901. Reputedly haunted by various phantoms, including an eighteenth-century coach and horses that pulls into the lay-by opposite, its occupants alight and then fade away. A little further towards Radlett is the former Kendal's Hall, now Radlett Preparatory School. A house has existed on the site for centuries. the existing building was built by Robert Phillimore at the end of the eighteenth century. The last Phillimore left Kendal's in 1926 and in 1980 it became a school.

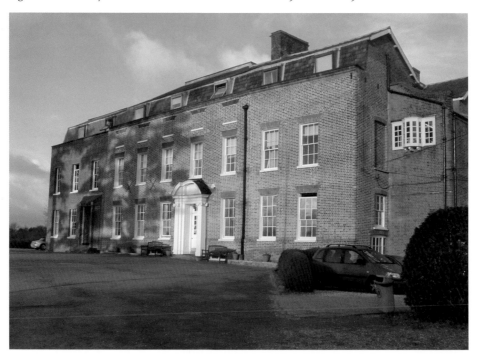

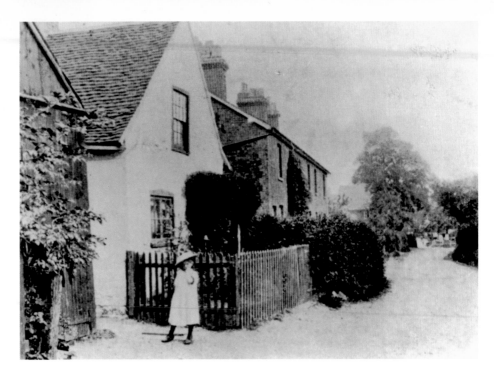

Back Lane, Letchmore Heath

Back Lane, Letchmore Heath from a photograph *c.* 1905. Back Lane contains the village's oldest residences, and has changed relatively little since 1905. The Old Rest is reputedly the oldest. The Old Tythe Barn officially dates from the 1640s, but is probably much earlier.

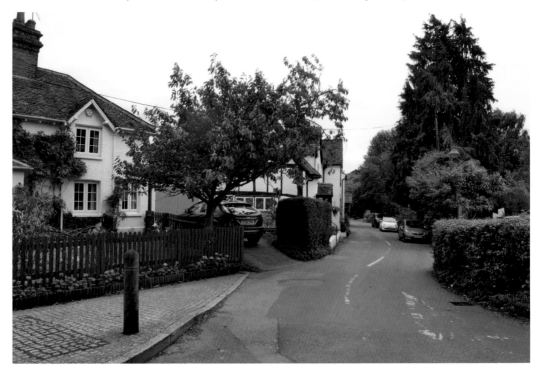

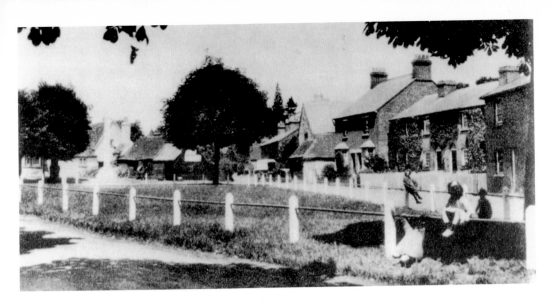

The Village Green, Letchmore Heath

The village green, Letchmore Heath, *c.* 1900 and today. The village green remains almost completely unchanged since Victorian times. The Three Horseshoes, facing the green, dates from at least 1586, with a substantial reconstruction in 1803.

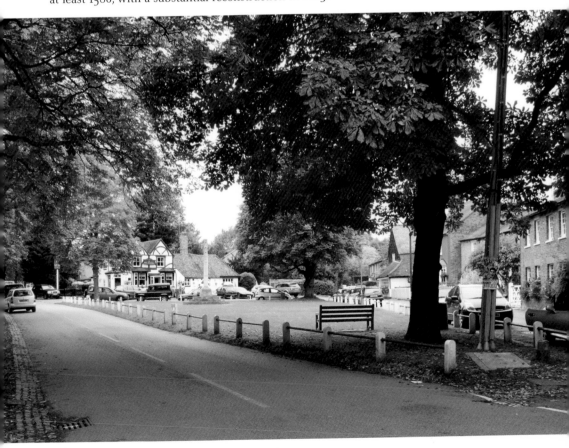